The aim of this workbook is to teach you how to draw pleasing nightscapes as shown below. Though they look involved, they are based on simple techniques for drawing night sky and other elements and after completing this workbook, you will be able to enjoy doing these pleasing nightscapes and connecting with your creative side.

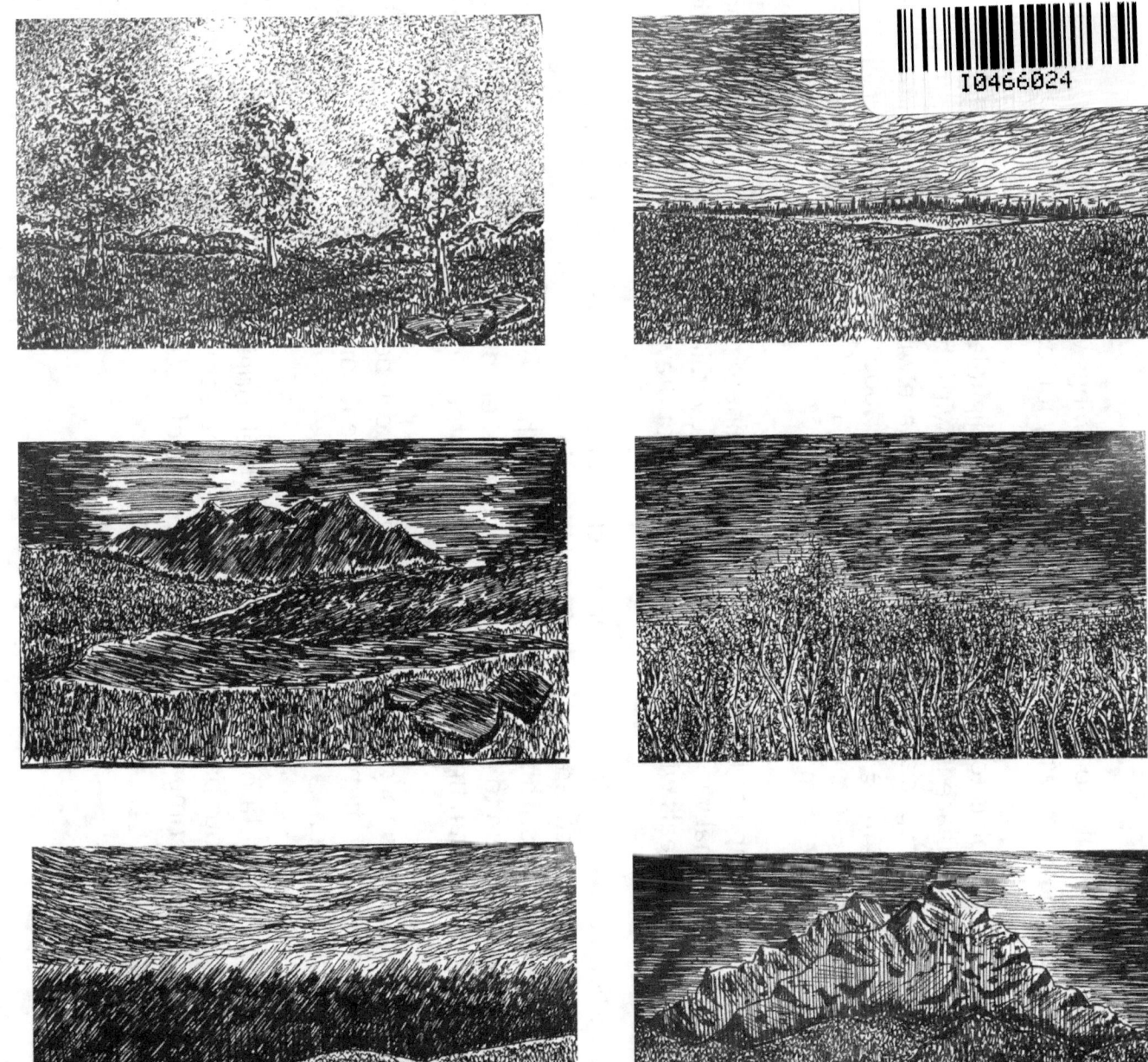

Hi,

Thank you for the purchase of this workbook. Doing simple drawings with pen and ink is a very relaxing and enjoyable hobby, and with this workbook, you will soon discover how easy it is as well.

The primary aim of this workbook is to teach you how to draw night landscapes. The darkness and faintly visible light of a pleasant night holds a special place in our hearts and my aim with this workbook is to show strokes and techniques that can be used to express that special feel and emotions we have with night. A night landscapes is not only about expressing darkness (though it can be that) but is also primarily about setting a mood between interplay of darkness and faint intensity of light. In the following pages, we will cover lot of different techniques to capture these aspects and express them through simple medium of pen lines.

In a night landscape (or nightscape as I call it), Sky holds a prominent place. Indeed, it is the rendering of Sky (strokes used, distribution of light via tonal variations etc.) that sets the overall mood of the drawing. With this in mind, considerable part of this book deals with different techniques for drawing a night sky.

In addition to Sky, ground and other foreground and background elements also play important roles in giving a nightscape its appeal. These are covered as well though keep in mind that these elements are not covered in detail in terms of their basic drawing steps. This is covered in detail in other volumes of my workbooks series. What is focused on in this book is how to texture them to give them a feel of night. I encourage you to consult other volumes in the series to learn how to draw them. You can find more information on other volumes at **www.pendrawings.me/workbooks**

Special consideration is also given to 'composition themes' that can be used as a starting point for your drawings. These are some of the ways different elements can be combined to create an effective nightscape. After you try these, try some others from your imagination.

The size of drawings in this book is around 3 by 4.75 inches (their original drawing size). Carry a pocket sketch book with you and try to attempt them in your breaks or whenever you find some time. If initial attempt is not to your liking, then try again. Don't be afraid to experiment and enjoy the process of discovering your creative side.

Happy Drawing,

Rahul Jain
www.pendrawings.me

Note on Pen and Paper:

So, what is a good pen for drawing?

Quite frankly, in the beginning, any good 'gel' pen will do, kind you will find in any local stationary shop. Choose one with fine tip (0.5mm wide or less) if you can find one. Gel pens for writing are often medium tip (0.7 mm) and their lines are often too thick to get good texture. As you progress in your journey and you desire better quality pens for drawing, you can check out my website and videos for more information.

www.pendrawings.me/penpaperchoices

Another great option is 'fine liners', which you can easily find with fine tip. One very popular brand is 'Pigma Micron', but to reiterate, any good fine point gel pen or marker/fine liner will do in the beginning.

I would suggest not using pencil. Most pencils don't give sufficiently dark lines that you need to create texture with lines alone. Permanence of pen lines also promote good observation and avoid 'draw-erase-draw' cycle that frustrates many beginners. Use of ordinary ball pen is also discouraged as their ink is not dark enough to enable proper texturing, especially the darker tones of a nightscape.

Most importantly, make sure that you don't get discouraged from trying activities in this workbook because you don't have a 'good quality' pen.

As for paper, in addition to this workbook, any normal paper like the one you use for normal printing will do. Avoid textured paper as this will interfere with flow of nib. Choose a smooth paper instead. There is again an incredible variety of paper available for drawing and you can find discussion on relative merits of these for pen and ink drawing at the above link.

Note on Proper Use of Pen for Drawing:

A key aspect of drawing with pen is to let your pen float on the paper with the nib/tip touching and releasing ink.

Never dig into the paper by pressing nib/tip in the paper.

Hold your pen lightly and release the tension in your hand. This will help you get the freedom of pen movement and lightness that contributes to good drawing practice.

A good quality gel pen and marker will provide a nice line with gentle touch on paper. If you find that you need to dig to get the ink out, then change the pen. 'Forcing' ink out of pen is never recommended. It will ruin drawing paper and create hard lines and ruin the drawing experience for you.

In the following pages, different pen strokes are illustrated that can be used to convey different textures. When attempting them, keep your hand supple and most importantly, keep it moving. The stroke shouldn't be done in a slow and deliberate manner, as this makes it rigid and un appealing. At the same time, don't rush through it. Find your speed and rhythm at which the pen line has a natural appeal. This takes time and practice and you will soon find yours.

Importance of Viewing Light and Drawing Size :

It is very important to view night landscapes with in direct light, i.e. the light should not fall directly on the drawing.

This is because nightscapes have much darker tones and direct light falling on such drawings messes up our perception of relative darker tones in these drawings. Use only reflected light for viewing these drawings. You will know when the light is right when viewing these drawings.

Another aspect to consider is the level of detail that you want to incorporate in your drawing, especially the tonal variations that you want to incorporate in the night sky. With bigger drawing area and finer drawing nib, more details including finer tonal transitions can be incorporated in the drawing. This helps to bring out the desired feel in the drawing. But as we will see in subsequent pages, very pleasing night drawings can be done at relatively small size of 3 by 4.75 inches. Such size can be easily attempted in a pocket sketch book that can be carried anywhere and the drawing can be finished relatively quickly to get a satisfying feel. I would suggest drawing initially at this size and as you progress in your journey and want to incorporate more details, you can attempt drawing at bigger size. The strokes and techniques discussed here can be used for drawings at different sizes, unless noted otherwise.

When you come across a pen and ink drawing on paper or screen, it is important to understand that if might have been 'scaled down', especially if you feel that the lines/textures in the drawing as you are seeing are too fine to be rendered. Pen and Ink Drawings with finer details are usually drawn much bigger and then their scanned image is digitally compressed/scaled down and used for printing purposes. Seeing such drawings will something make your feel discouraged as you may feel that finer details in such drawings are unattainable by you. But keep in mind that such drawings are usually drawn bigger and at that size, if you follow the techniques, you will be able to draw such details as well and on compression, your drawing will convey such feel as well.

Most of the drawings in this book are printed at their original drawing size. This is so that you can feel comfortable drawing them as you view them Fine gel point pen (0.4mm) is used to draw them.

On Pen and Ink Drawing Style

If you had a chance to look at pen and ink drawings by different artists, I am sure one thing you would have noticed is the different 'style' of such drawings. The 'style' of a drawing is a loose term that generally refers to the way pen strokes are used to lay down tone and overall feeling the drawing evokes. In one aspect, Pen and Ink appears to be a very simple medium as a simple 'line' is used to lay down tone. But with this simplicity comes immense possibilities as there are limitless ways in which a 'line' can be drawn and used. At one end, there is 'Stippling' or 'Pointillism' where instead of line, multitudes of small dots are used to lay down tone. At the other end is use of bold brush strokes, usually used for drawing comics. In between, there are limitless ways in which lines can be drawn and used to create different feel for the drawing.

My 'style' and the one I present here is based on the use of simple pen lines to create what I call a 'pleasing' drawing. The size is often around 8 by 6 inches or less and is something that can be easily done in a small sketch book that can be easily carried around. What I recommend is to carry a pocket sketch book and pen with you and attempt these drawings in between your small breaks or whenever you feel like it. I don't aim for 'realism' in my drawings or instructions here. Such drawings are often done at much larger scale in a studio setting in slow deliberate manner. While you may eventually get there, my aim with the techniques and style presented here is to help you adopt pen and ink drawing as a relaxing and creative hobby that can be enjoyed anywhere. This means that my style and one presented here is aimed at use of simple pen lines at a small reasonable drawing size that can be attempted anywhere.

As you attempt the techniques and experiment with drawing with pen, you will develop your own style. Your drawings will look different than mine and that is completely fine. Indeed, your own 'style' might evolve over time as well. The key point is not to copy my drawings but instead to understand the key aspect of stroke as illustrated and then use it in your own manner.

If you feel frustrated, then take a break and try again. Persistent daily practice is key to improvement. Soon you will develop your own style and discover the joy of putting pen on paper and bringing to life the imagined or real landscape on a piece of paper.

Content:

- Drawing Night Sky, Technique 1 8
- Drawing Night Sky, Technique 2 24
- Tonal Variations in Night Sky 31
- Drawing Night Sky, Technique 3 37
- Drawing Night View of Mountains 45
- Drawing Night View of Ground 29
- Additional Techniques for Texturing Ground 56
- Composition Themes for Nightscapes 63
- Drawing House in Perspective 90

Drawing a Night Sky: Technique 1

Drawing clouds and sky is discussed in detail in other volumes in the workbook series. Here we will discus how those techniques can be extended to depict a night sky. Mostly it involves using more strokes to give the sky a darker tone and leaving areas around moon lighter to bring out the night feel.
One of the simplest technique is to use dots and small tick marks for indicating sky. By adding more of them, darker tone as desired can be obtained.

↓ Stroke used. Use more of such dots and ticks to build up the tone.

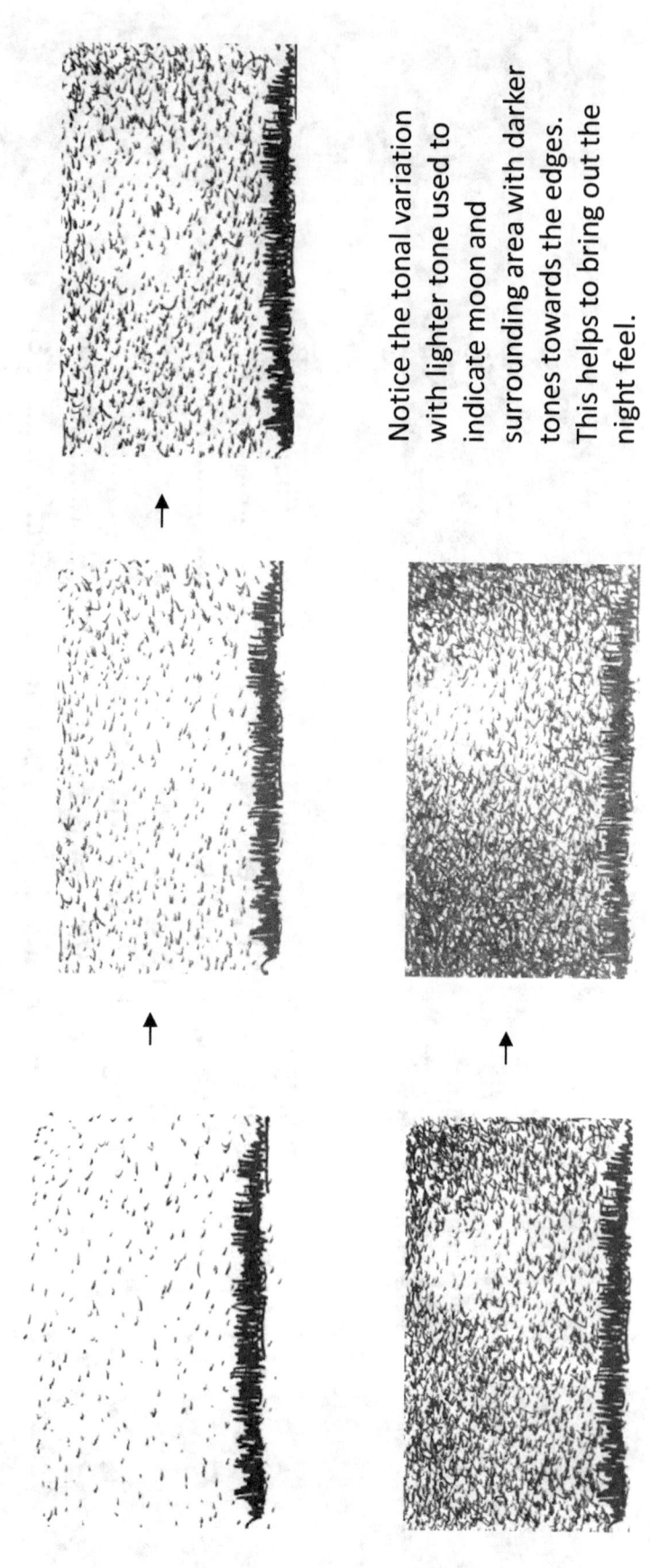

Notice the tonal variation with lighter tone used to indicate moon and surrounding area with darker tones towards the edges. This helps to bring out the night feel.

Activity: Drawing a Night Sky using Technique 1

Starting points are provided below to add further strokes to bring a feel of night sky. Try some of your own.

Drawing a Night Sky: Technique 1 Drawing

Following is a drawing where small dots are used to render night sky. Don't finish one area at a time. Instead, lay down initial tone to all the sky area and then successively build tone by adding more dots. This way tonal match between different areas is always in view and can be properly adjusted as the drawing proceeds.

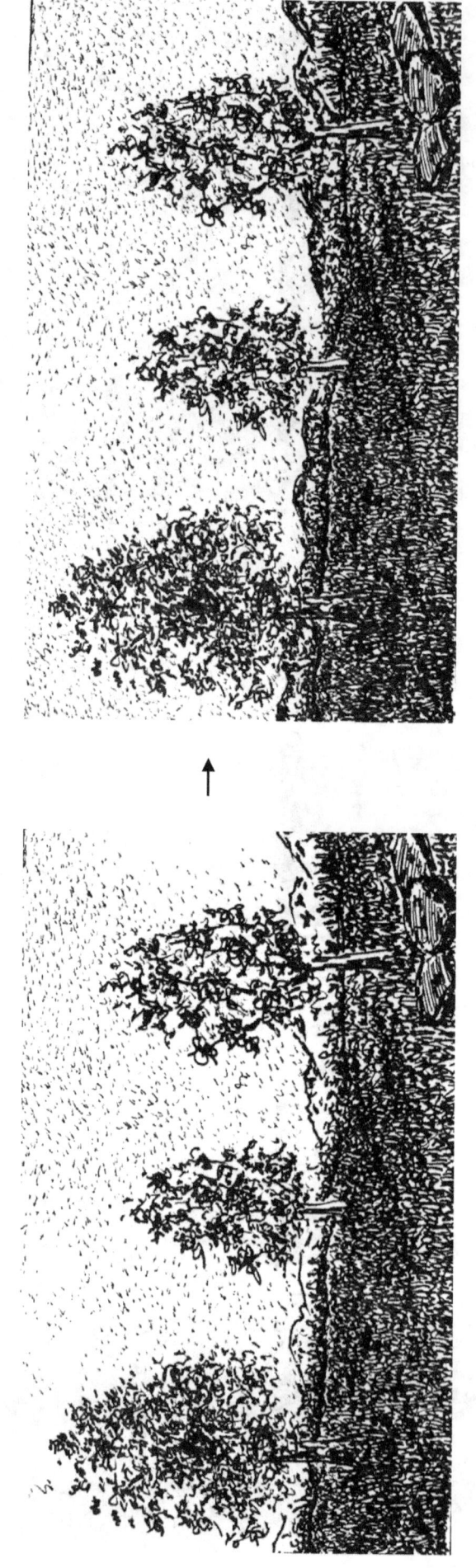

Use dots and small ticks to lay down initial light tone in all of sky.

Use more dots and small ticks to add tone.

Drawing a Night Sky: Technique 1 Drawing Finished

Adjust the tones as discussed before making the edges darker and area around moon lighter. Level of tone is also a matter of personal preference. Lighter tone like on top right gives more of moon lit effect where as darker tones like on bottom left gives more intense effect. Use of dots also makes the sky still compared to other strokes that gives it more movement (as we will see later). The tree foliage is also sufficiently darkened to distinguish against the night sky. Don't darken the sky to the same level as tree foliage.

Drawing a Night Sky: Technique 1, Alternate Strokes

Instead of dots, which are bit time consuming to do, tick marks can also be used. Different sizes of ticks used will give different feel and as the size increases, it gives more of 'coarse' feel to the night sky compared to fine dots. This brings out different feel in the drawing. Experiment with different sizes of ticks to see what you prefer.

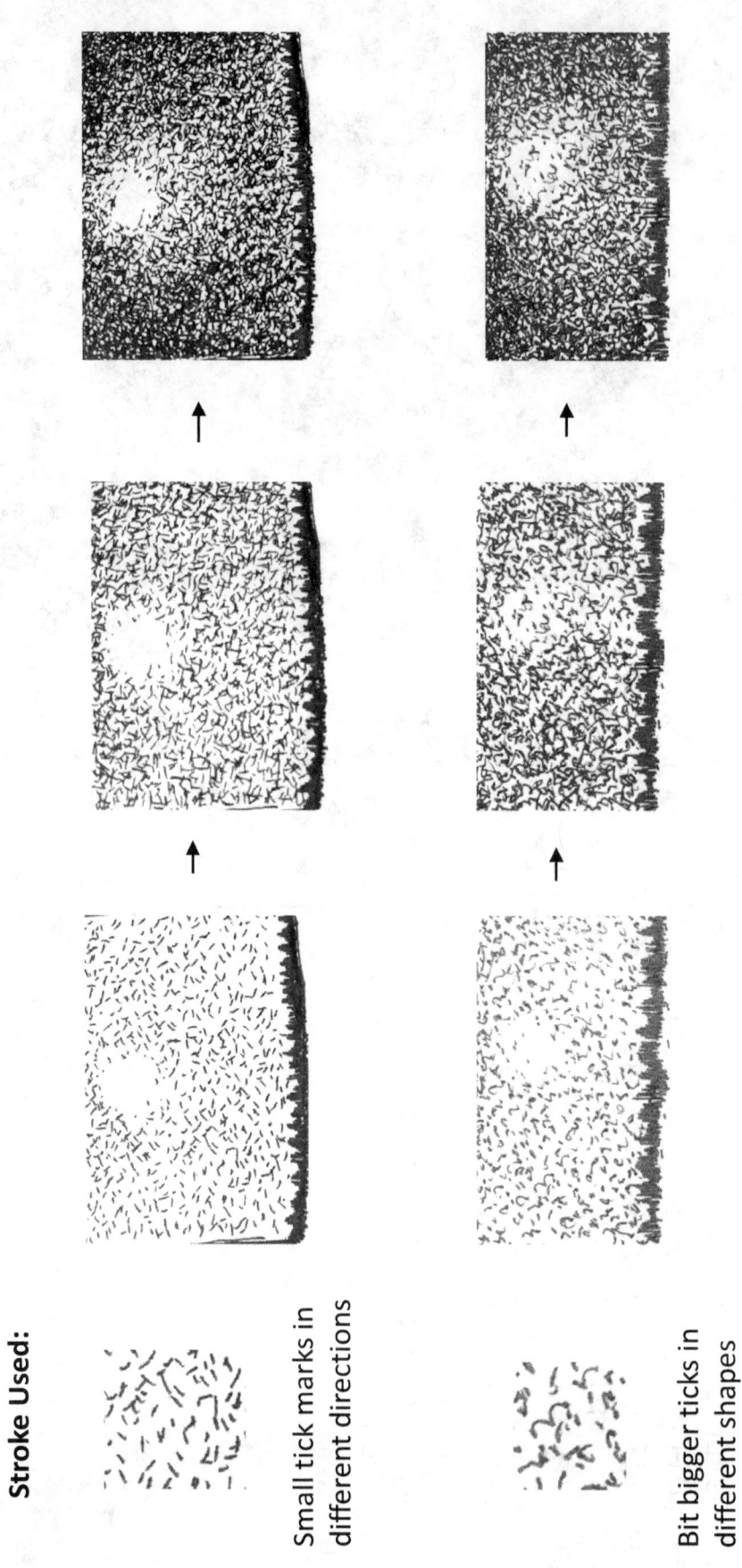

Stroke Used:

Small tick marks in different directions

Bit bigger ticks in different shapes

For more information visit www.pendrawings.me/getstarted

Activity: Practicing Alternate Strokes

Practice drawing night sky using alternate strokes discussed on last page. With a mix of dots, small ticks, even small whirls, there really is no limit to such strokes that can be used to render night sky. Try some below.

Render Night Sky using the stroke shown

Draw some of your own below.

For more information visit www.pendrawings.me/getstarted

Drawing a Night Sky with Ticks: Examples

Here are 2 drawings where different tick marks are used to render the sky. Different sizes of dots and ticks will give different effects. Experiment to see what you prefer.

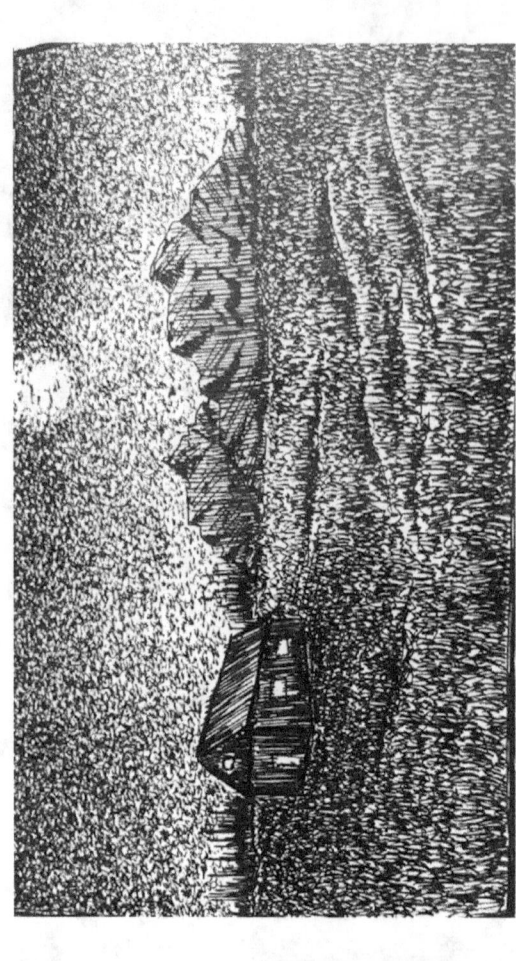

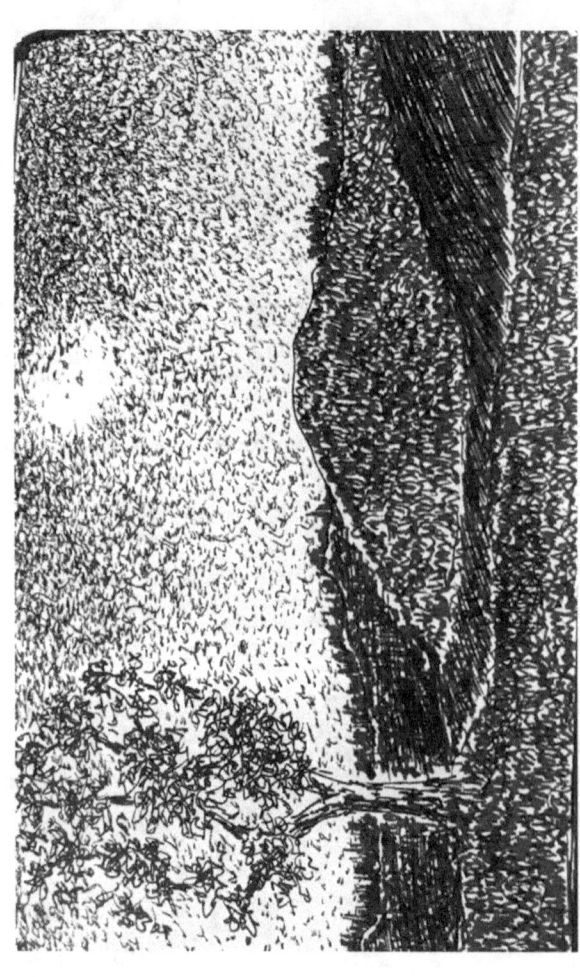

Notice also less darker tone used in the left drawing which gives it a feel of 'night glow'. In the right drawing, edges are made more darker but still ample lighter area is left to give it a night lit effect.

Drawing a Night Sky with Ticks and Dots:

Finer dots and ticks can even be mixed with dots used in lighter areas and bigger ticks used in darker areas. Smaller dots take lot of time to bring up darker tones and this approach of using coarser ticks in darker areas is quicker and gives the same result.

Finer dots in lighter areas

Bigger ticks in edges to build up tone

Lot more lighter area is used in this drawing compared to others we saw earlier. This gives a further 'lit up horizon' kind of feel and this is carried over to land by using lighter tone for ground cover in front of it. Try such different combination of tones for your night sky to see the feel they evoke.

Drawing a Night Sky: Using Scribble

In last few pages, we moved from using fine dots to tick marks for depicting night sky. This can be taken further and scribble lines used as well. This is fastest way of drawing night sky as the pen doesn't have to be lifted from paper. It gives an intense feel to night sky compared to use of fine dots as seen below.

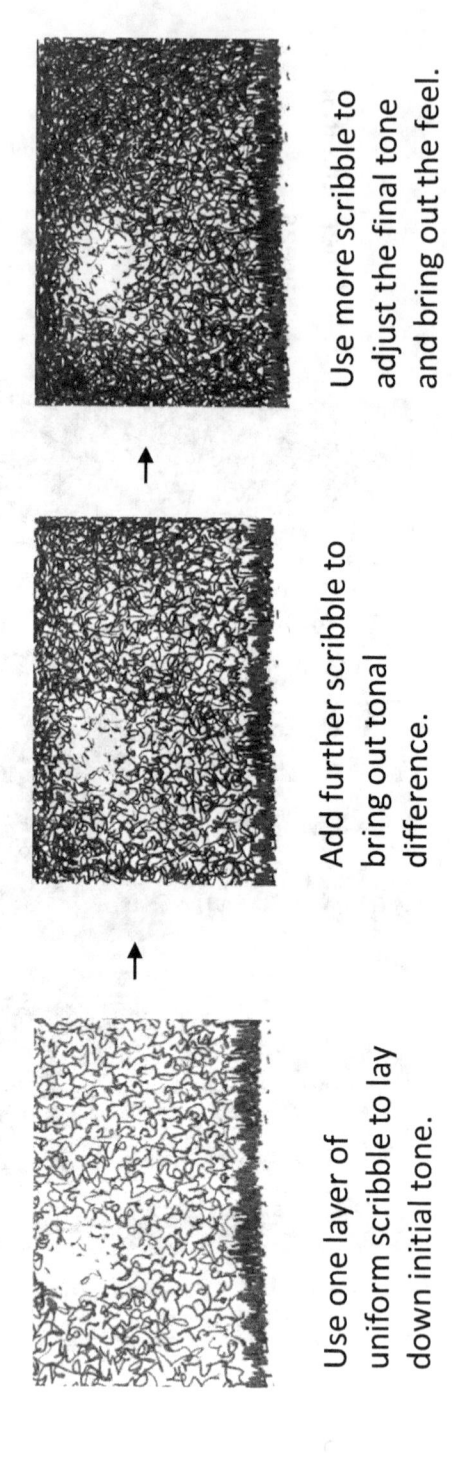

Use one layer of uniform scribble to lay down initial tone.

Add further scribble to bring out tonal difference.

Use more scribble to adjust the final tone and bring out the feel.

Activity: Using Scribble

Practice drawing scribble stroke below to render the night sky.

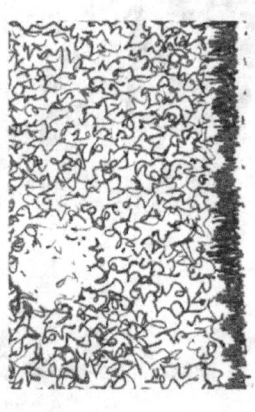

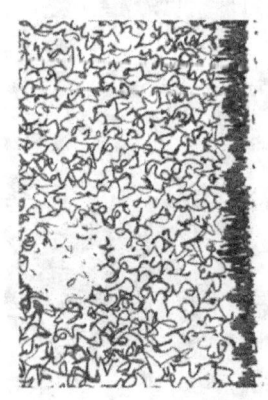

Drawing a Night Sky with Scribble: Example

In the following drawings, scribble is used to render night sky. Notice that it gives a bit 'coarse' effect compared to earlier drawings but is very effective at creating a darkened night sky. Here the tone is darker compared to earlier drawings but still lighter area is left near horizon and mountains to give it a feel of 'glow'.

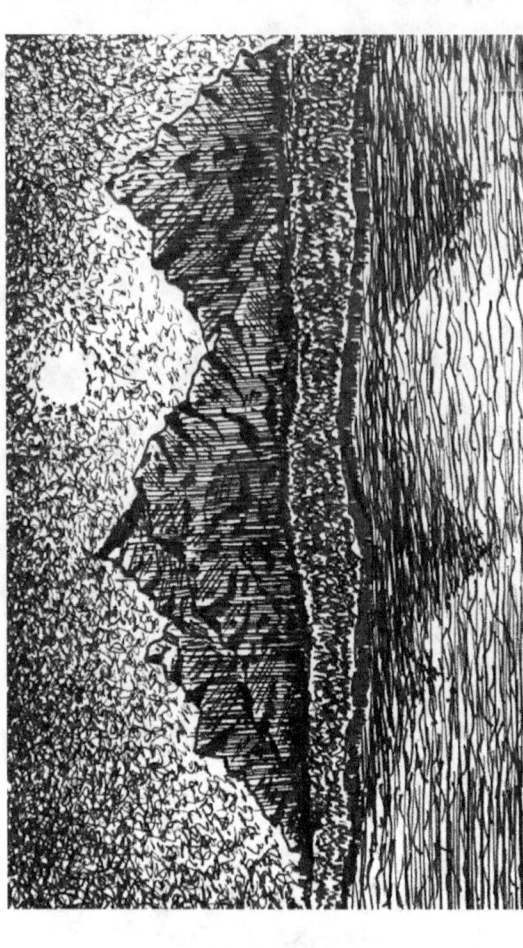

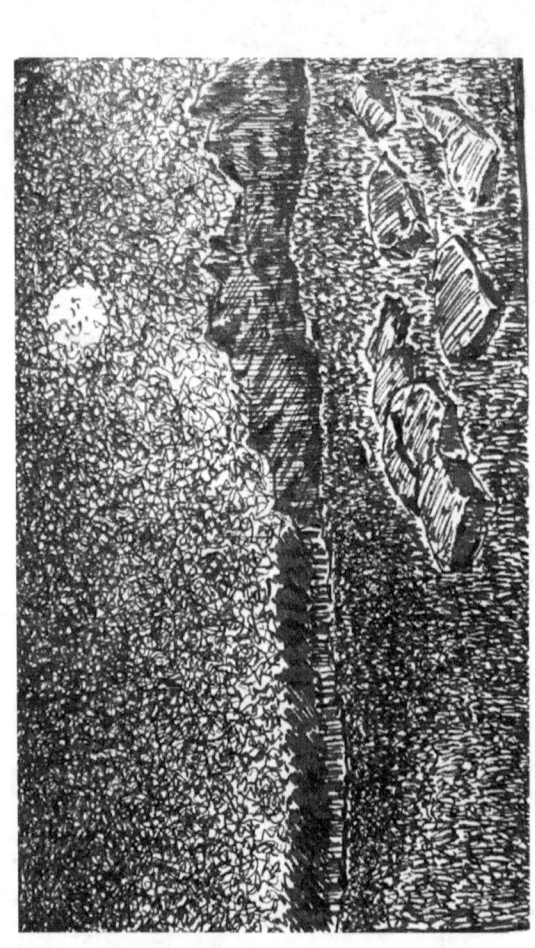

Use of other elements to create finished landscapes is discussed later.

Side by Side Comparison:

Here is a side by side look at using finer dots and ticks (left drawing) vs. more coarse scribble stroke (right drawing) for texturing night sky. As discussed before, fine dots and ticks gives more 'still' and 'relaxing feel' where as more bigger strokes give more 'coarse' and dynamic feel to the sky. They are used with river in the right drawing where they complement the movement of water.

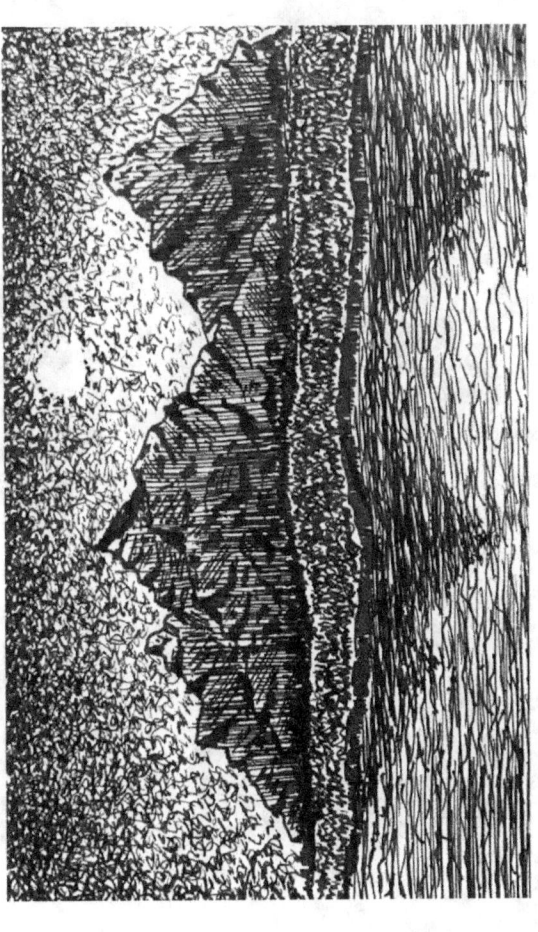

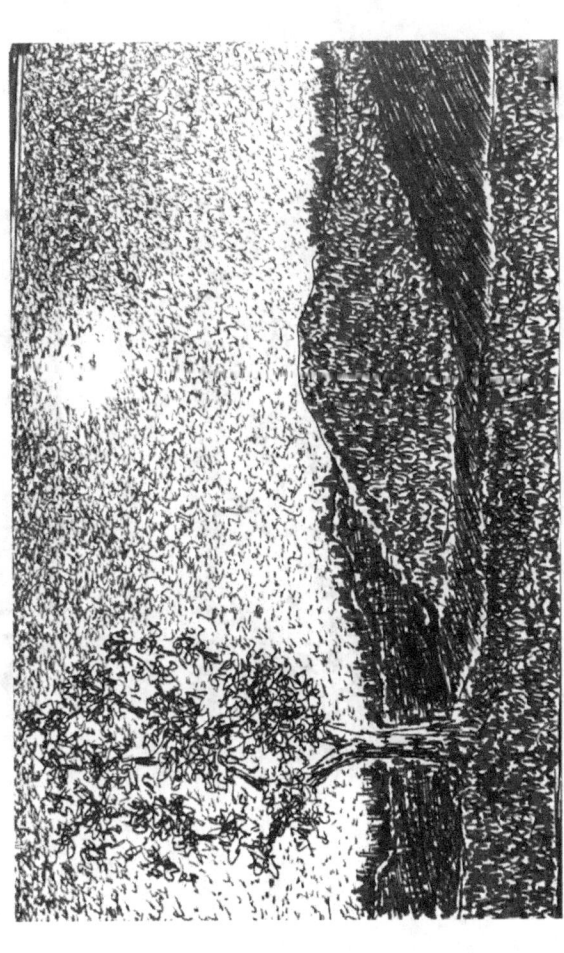

Nature of stroke, along with its manner of usage (level of darker tone, distribution of darker and lighter areas etc.) along with other elements used in the drawing all go towards establishing the mood of the night landscape. Experiment with different choices to bring out the desired feel in your drawing.

Relative Darkness of Night Sky:

As mentioned before, there should be a tonal variation from darker to lighter area around Moon to bring out a nice night effect. Level of overall tone though is a matter of personal preference. In the following comparison, additional darker tone is successively added to give it more intensity. Experiment with your drawings to see the level of darker tones your prefer.

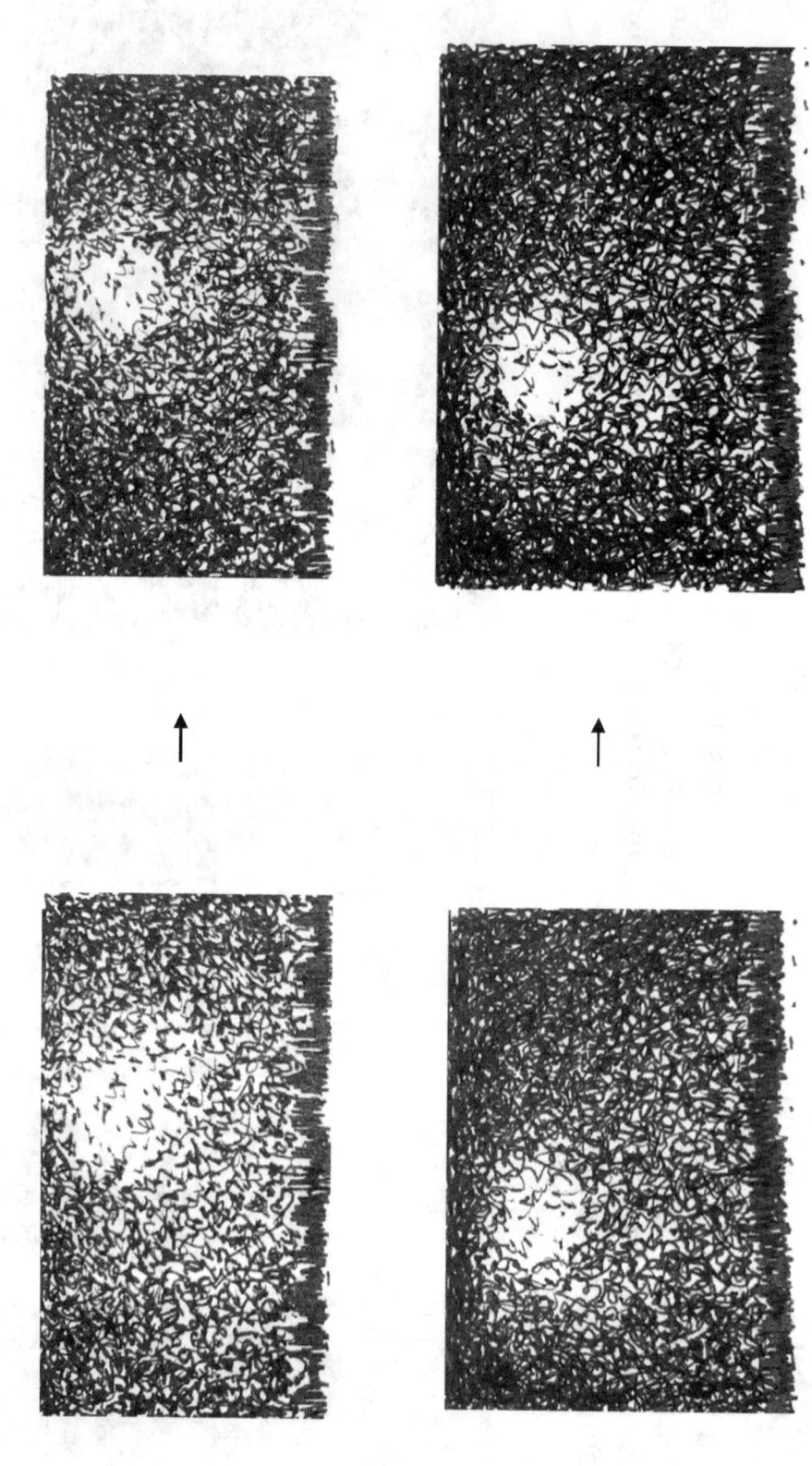

Practice: Drawing Different Darkness of Night Sky:

Add more strokes below to bring out different levels of darkness of night sky. Experiment to see what you prefer.

Relative Darkness of Night Sky: Example

In the second drawing below, more darker tone is added by using more scribble stroke to give a very dark tone to the sky. The 'glow' is also taken away by leaving no lighter area. This give more intense feel as can be seen below. Different levels of darker and lighter tones and their distribution evokes different feel in the night sky.

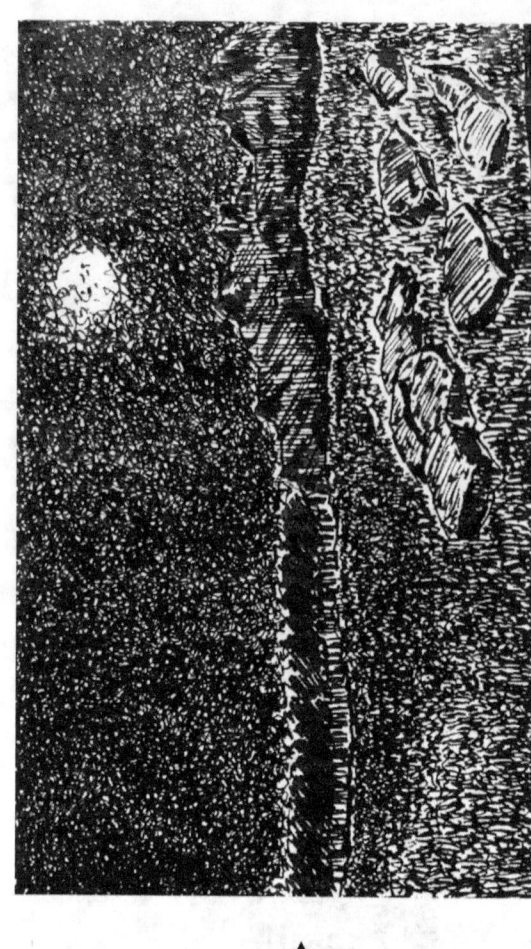

Although the overall tone is darker, notice that there is still a subtle tonal variation in the sky. This is important to give some depth and interest in the drawing.

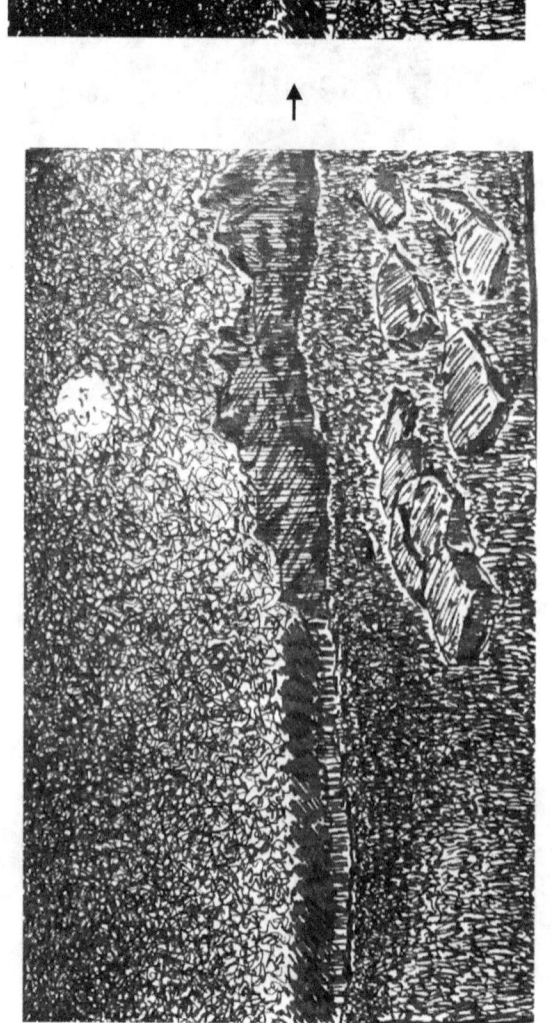

Importance of Leaving White:

In the absence of color, it is important to leave some white between different elements to distinguish between them otherwise they will blend into each other and make the drawing incoherent. Such fine band of white is usually ignored by our mind as it interprets the drawing but greatly helps to maintain visual coherence of drawing.

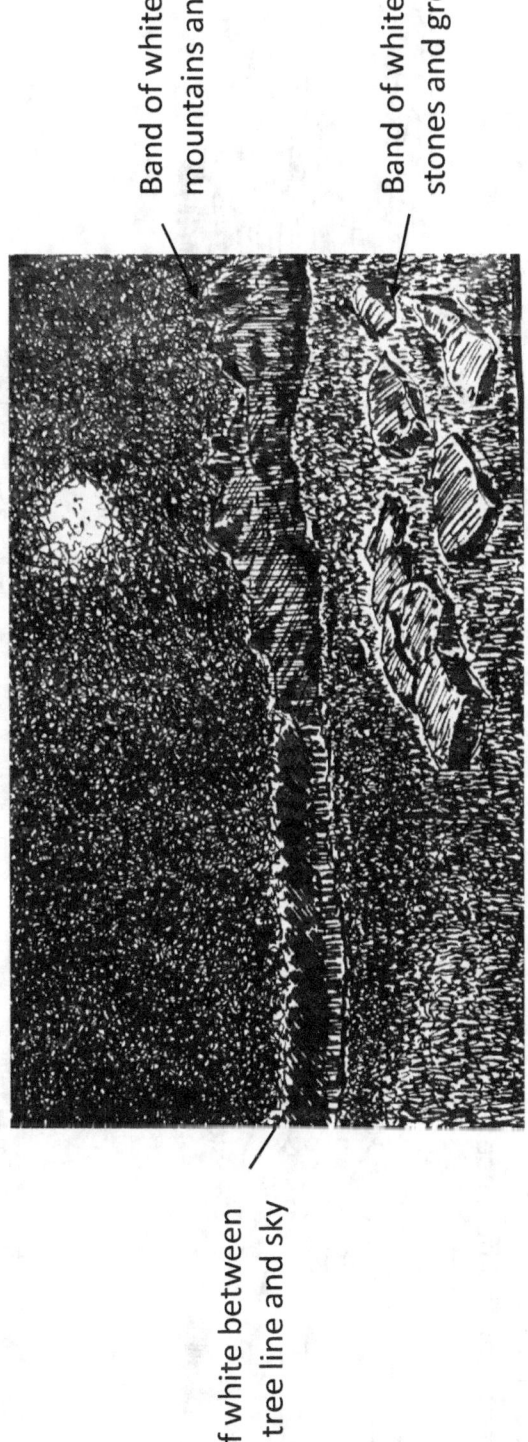

Band of white between mountains and sky

Band of white between stones and ground cover

Band of white between distant tree line and sky

Drawing a Night Sky: Technique 2

In this technique small wavy lines are used to indicate clouds. By using higher density of such lines, a feel of night sky can be indicated as shown below. Notice again how edges are darkened with gradual tapering of lighter tones towards the Moon area. By using appropriate density of lines, such tonal transition can be obtained, giving a nice feel of night sky.

This is the core stroke. Use more of this to create tonal difference.

Activity: Drawing a Night Sky Using Technique 2

Practice rendering the night sky below using technique shown on the last page.

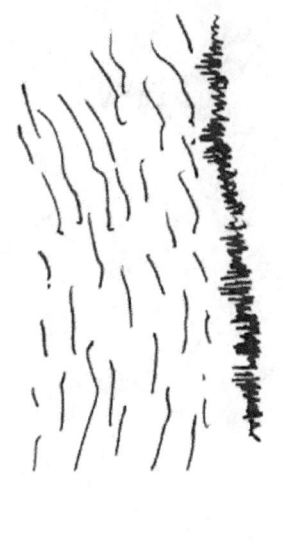

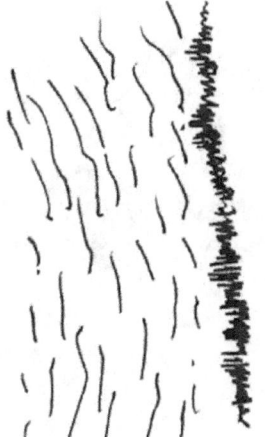

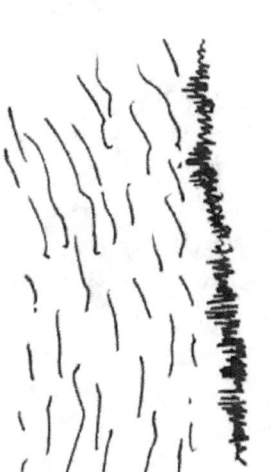

Drawing a Night Sky: Technique 2, Example

Following is another example at bigger size. Here the edges are not darkened as much as in last page. Level of tone is a personal preference, but it is important to have a transition of tones to give it a nice feel.

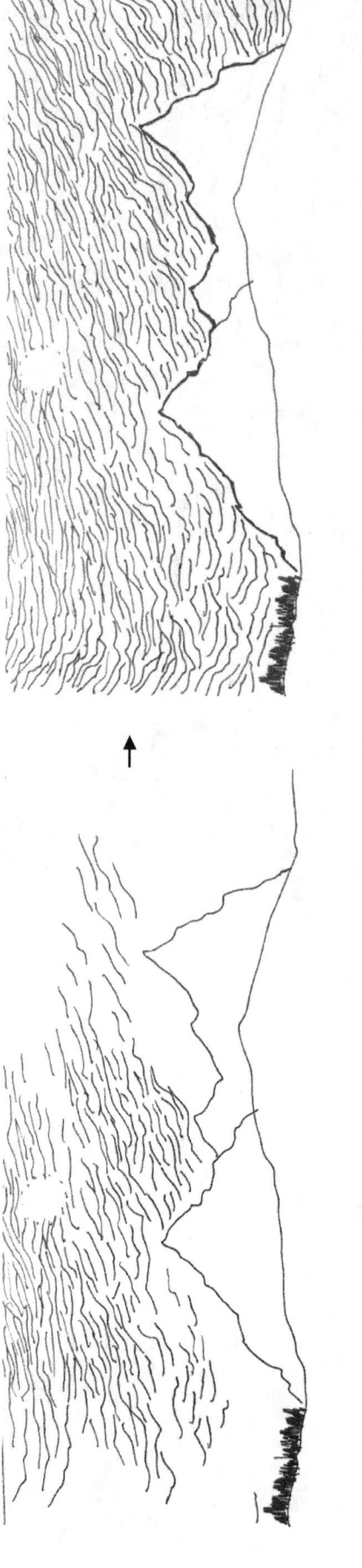

Use wavy lines as shown to texture the sky. Different sizes and orientation of such lines gives different effect.

Lay down an initial tone across all the sky. Bigger lines can be used near the top and smaller lines towards the horizon

Drawing a Night Sky: Technique 2, Continued

Avoid any specific pattern in drawing the lines. The best way to do this is to move from one place to another, doing little here, a little there and so on. Keep your hand moving to get irregular pattern.

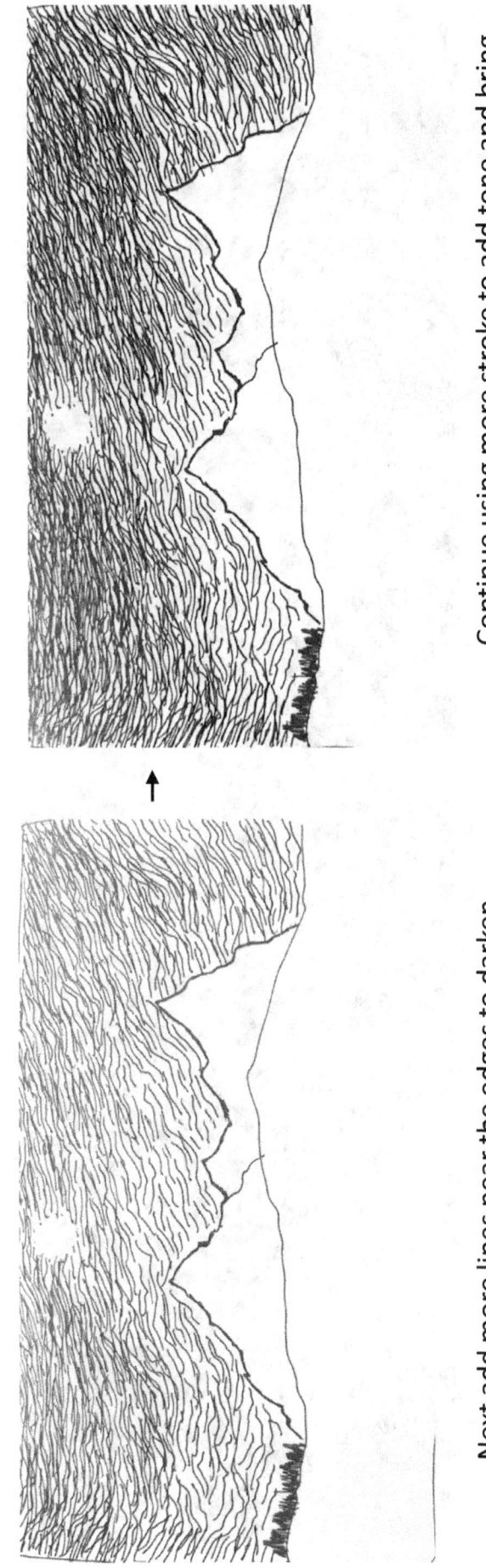

Next add more lines near the edges to darken them more.

Continue using more stroke to add tone and bring out the desired night feel in the sky.

Drawing a Night Sky: Technique 2, Finished

Use more stroke to adjust the tones and create tonal distribution.

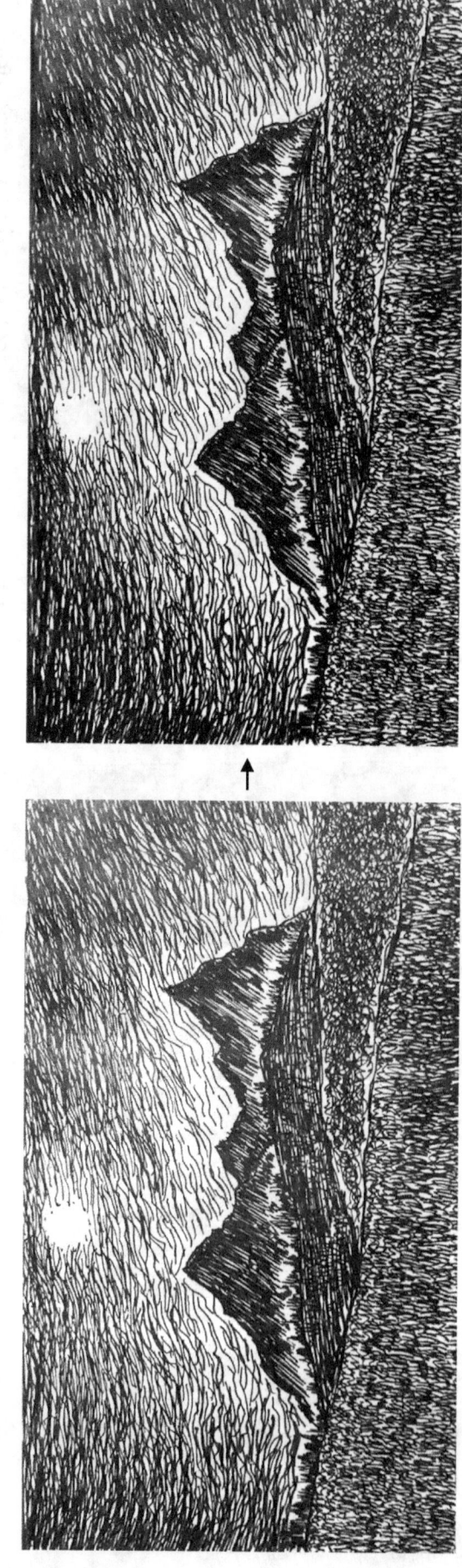

Activity: Practicing Technique 2

Starting is often the most difficult part. With that in mind, following shows a drawing where Sky is textured midway using technique 2 stroke discussed last. Add more strokes to bring out the feel of night sky as illustrated in last few pages.

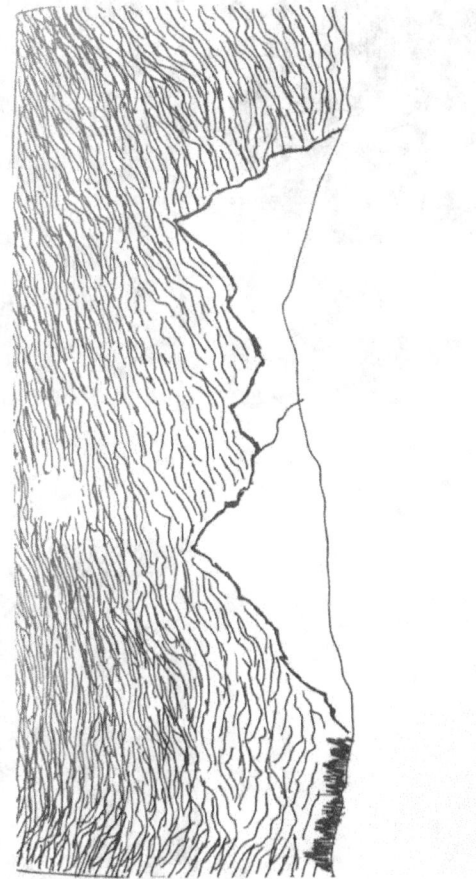

Drawing a Night Sky: Technique 2, Examples

Here are some finished night landscapes with sky drawn using technique 2. Notice how use of different angles and sizes for the wavy lines gives a different feel to the sky. Such lines also impart a feel of 'movement' and 'energy' to the landscapes compared to the first technique (use of dots) which inspires a still feeling in the landscape. Choose appropriate technique based on the feeling you intent to convey in your night landscapes.

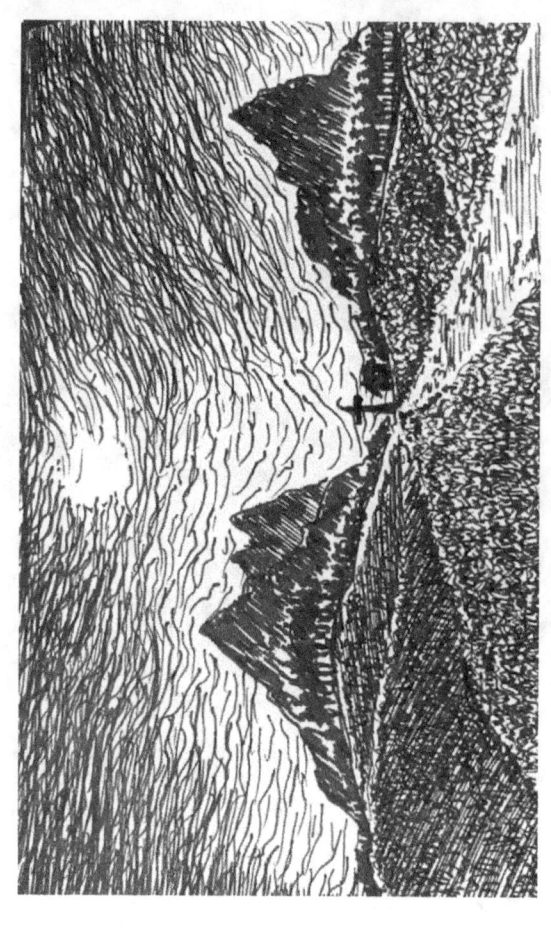
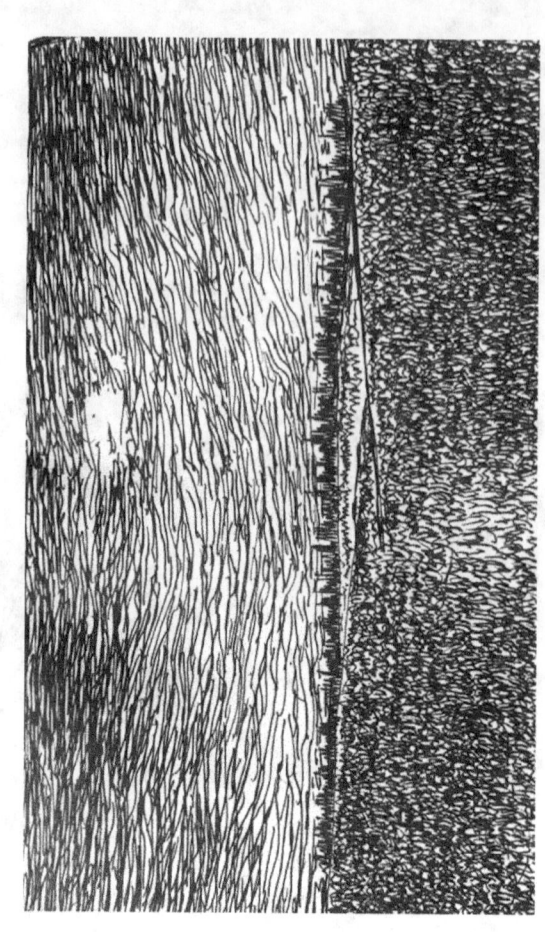
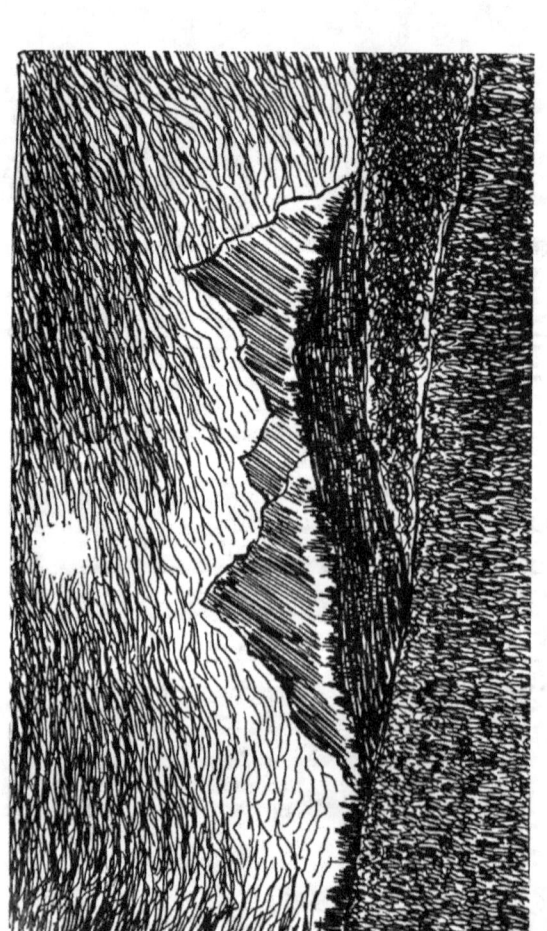

Alternate Tonal Variation in the Sky:

In the examples seen so far, a particular kind of tonal variation was used with areas around moon and horizon lighter and edges darker. While this works very effectively, there are many other types of night tonal distributions that can be used to create a different feel. Here is another type where elongated area around moon is kept lighter and this is punctuated by streaks of darker clouds.

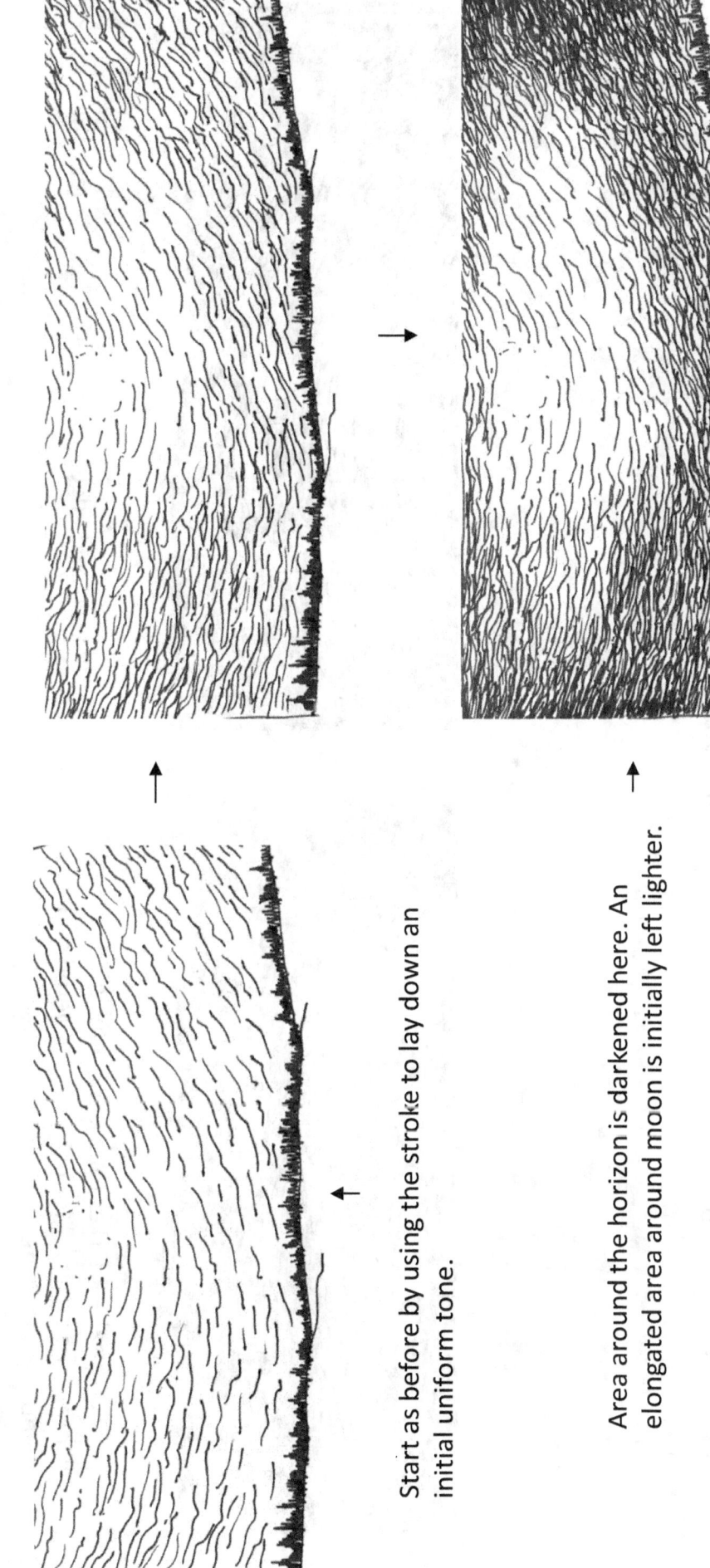

Start as before by using the stroke to lay down an initial uniform tone.

Area around the horizon is darkened here. An elongated area around moon is initially left lighter.

Alternate Tonal Variation in the Sky: Continued

Experiment with different tonal variations of night sky in your attempts to see the impact it has on the feel of the drawing.

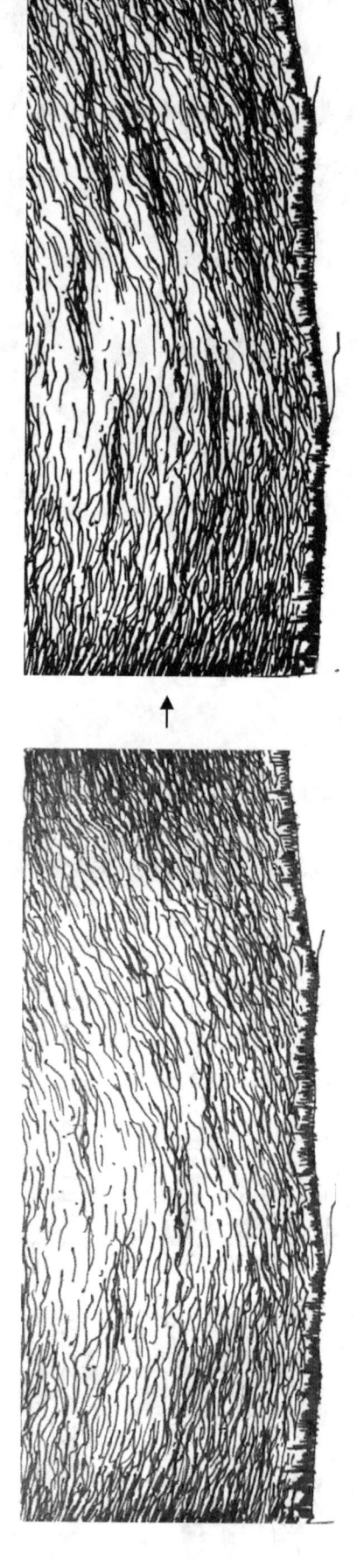

Next a streak of darker tone is introduced in lighter area around Moon. Make it tapered and randomly distributed.

Streaks and edges are made darker to make the night sky more intense.

Alternate Tonal Variation in the Sky: Finished

Experiment with different tonal variations of night sky in your attempts to see the impact it has on the feel of the drawing.

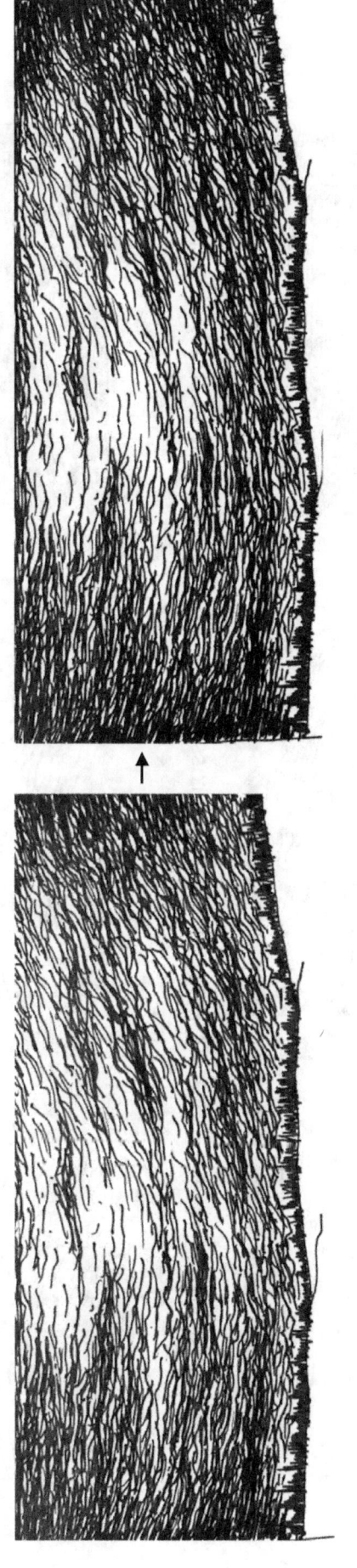

High contrast between a dark streak against a lighter area makes the night sky feel more intense.

More streaks with different level of darkness can further be added to bring out the desired feel.

Alternate Tonal Variation in the Sky: More Examples

There really is no limit to the interesting tonal variations that can be done for the night sky. Following are some more examples, Combination of stroke used, manner of its usage, tone used etc. all contribute to the feel of night sky. Study the examples below and try some of your own.

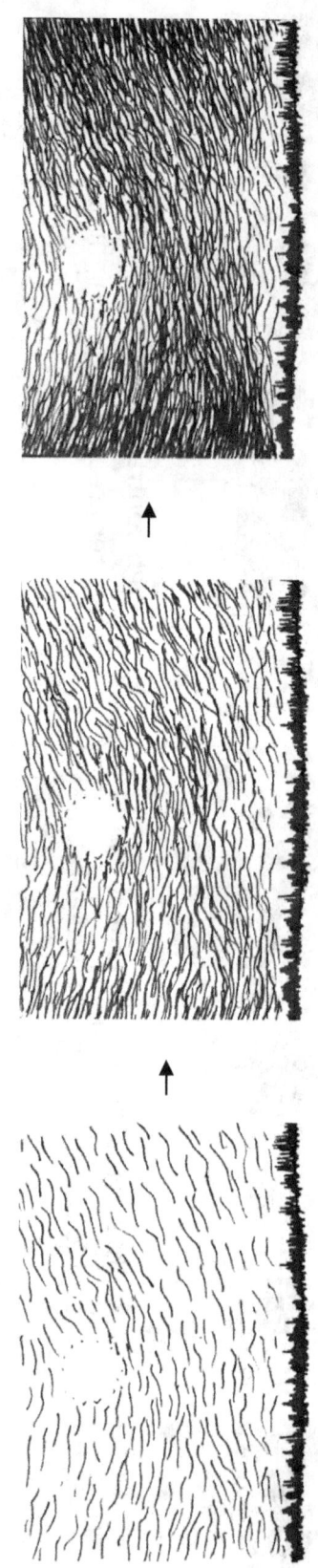

In the approach above, a band of darker tone streaks across the sky with lighter horizon and Moon area.

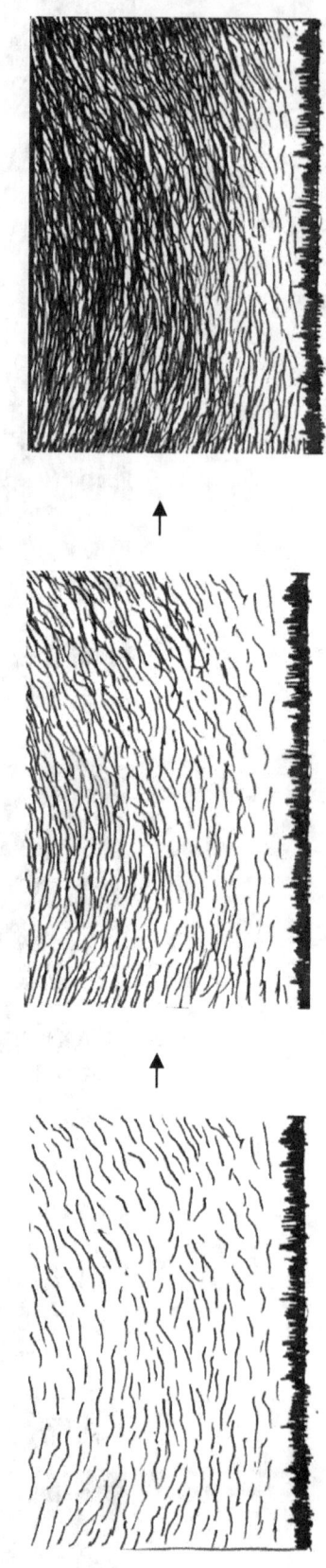

Here moon is not visible with makes the lighter area near horizon more dominant.

Alternate Tonal Variation in the Sky: Yet More Examples

Following are some additional examples. Try some of your own.

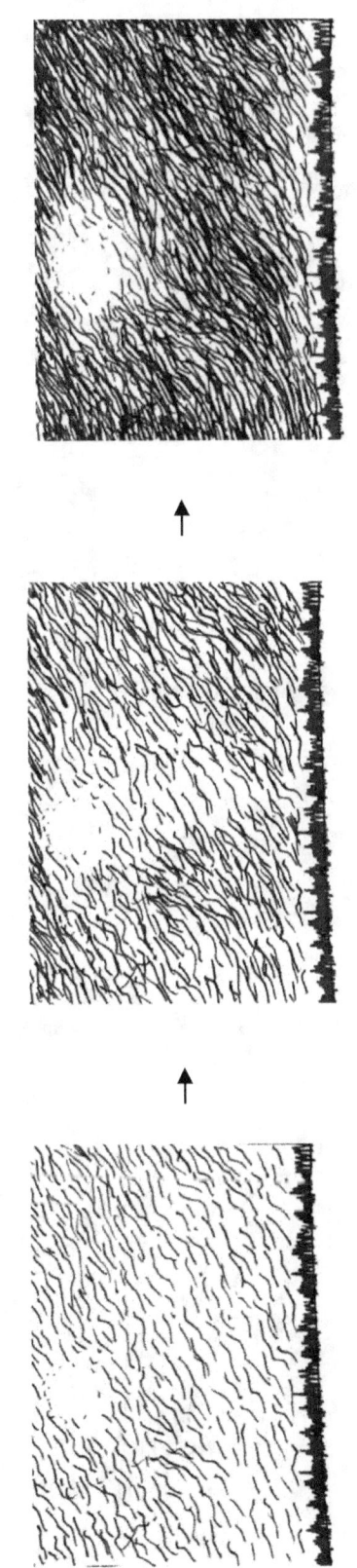

Here a 'wave' of darker tone is used in the middle which adds a sense of movement and energy to the sky.

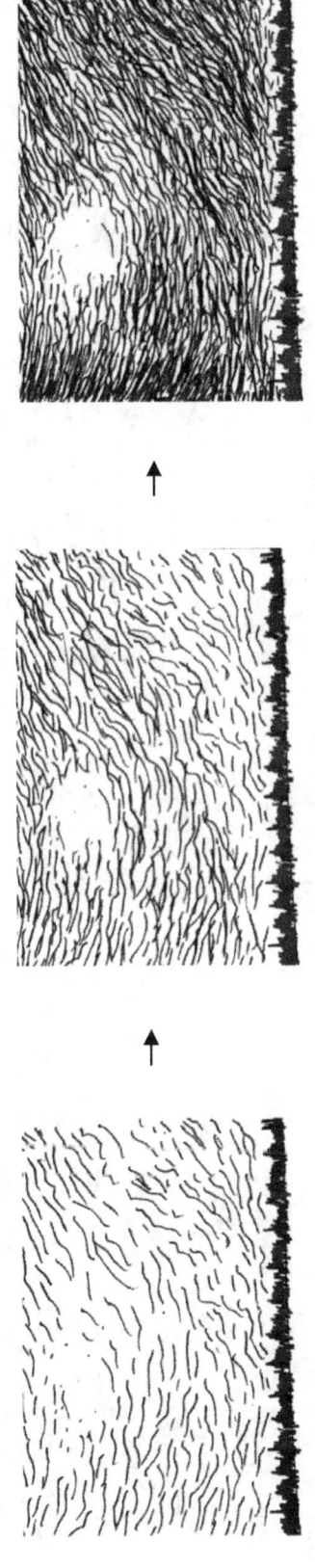

Another pattern that can be used to render a night sky.

Activity: Drawing Different Tonal Variations in the Sky

Practice drawing different tonal variations below as illustrated in last few pages. The feel of night Sky is THE most important contributor to the feel of a nightscape and different tonal variations as shown in last few pages contributes directly to setting the feel of night sky. Practice drawing them extensively.

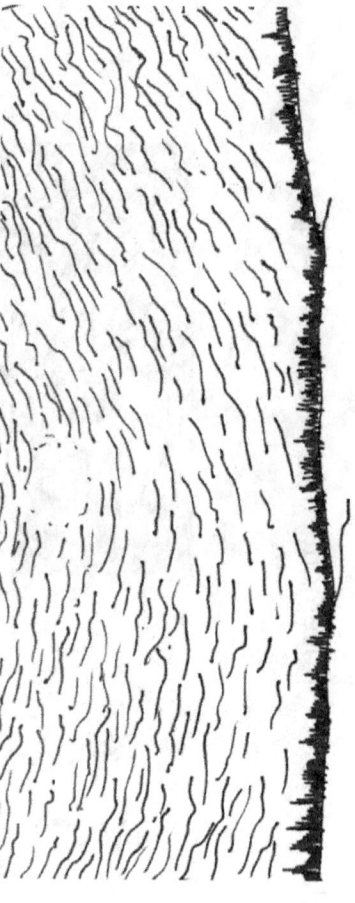

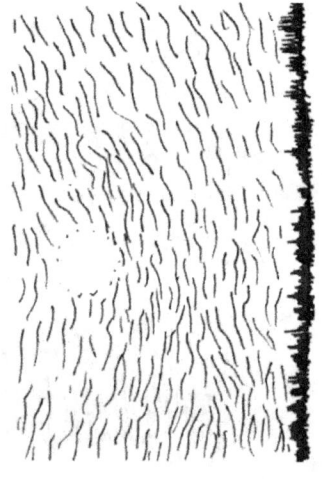
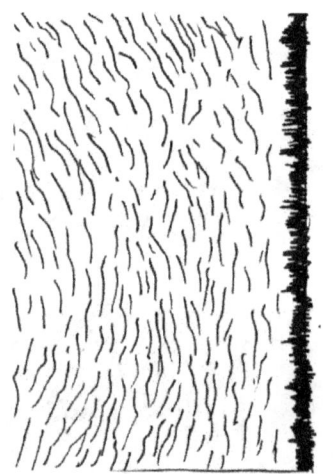

Drawing a Night Sky: Technique 3

In this technique, horizontal lines are used to render night sky. By using successive layers of horizontal lines, tonal transitions and a feel of night sky is obtained. To get a nice irregular pattern, add successive lines in different locations randomly.

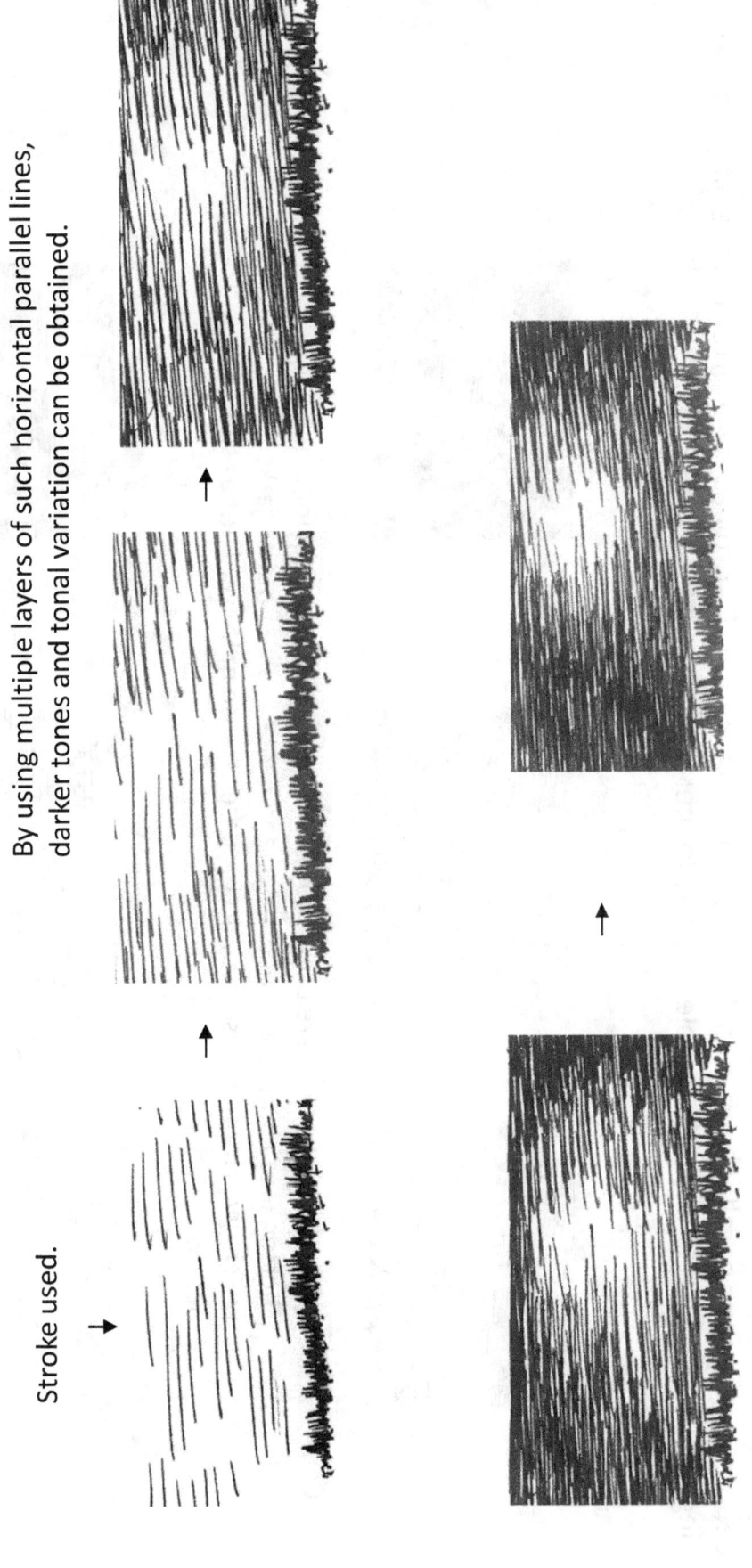

Stroke used.

By using multiple layers of such horizontal parallel lines, darker tones and tonal variation can be obtained.

Drawing a Night Sky: Technique 3, Variations

By changing the length of parallel lines used, a different feel is obtained as seen below. Unless you have sufficient practice, drawing longer parallel lines is challenging in the beginning. Start by using shorter parallel lines in the beginning and with practice you will be able to draw longer lines.

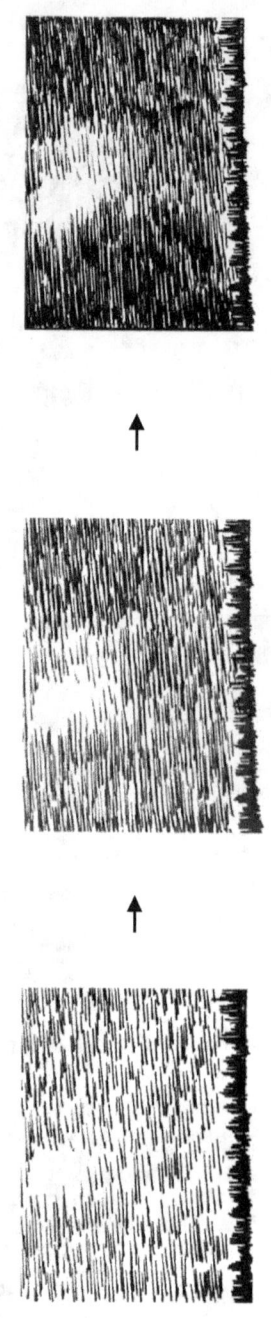

Shorter parallel lines are used above to create a different feel for night sky. Shorter lines create more of overlap and hence more spots of darker tones which gives more coarse feeling compared to use of longer lines as shown below.

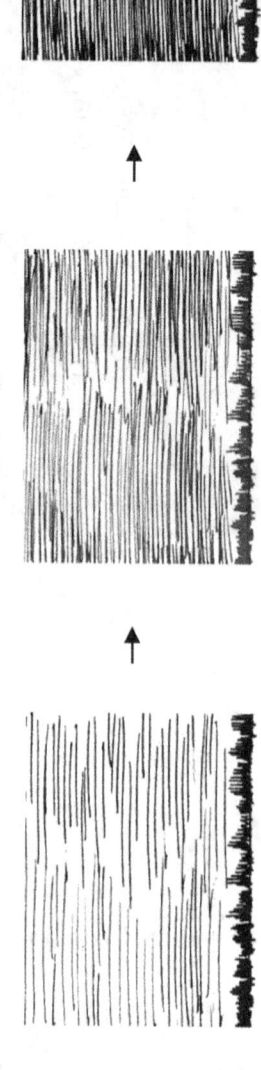

Longer parallel lines are used above. This creates a different feel.

Activity: Drawing a Night Sky Using Technique 3

Finish the following drawings to bring out feel of night sky using technique discussed last. Use different variations discussed before to bring out different feel of night sky.

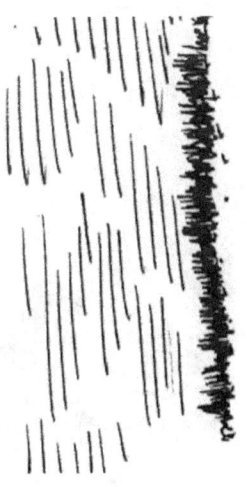

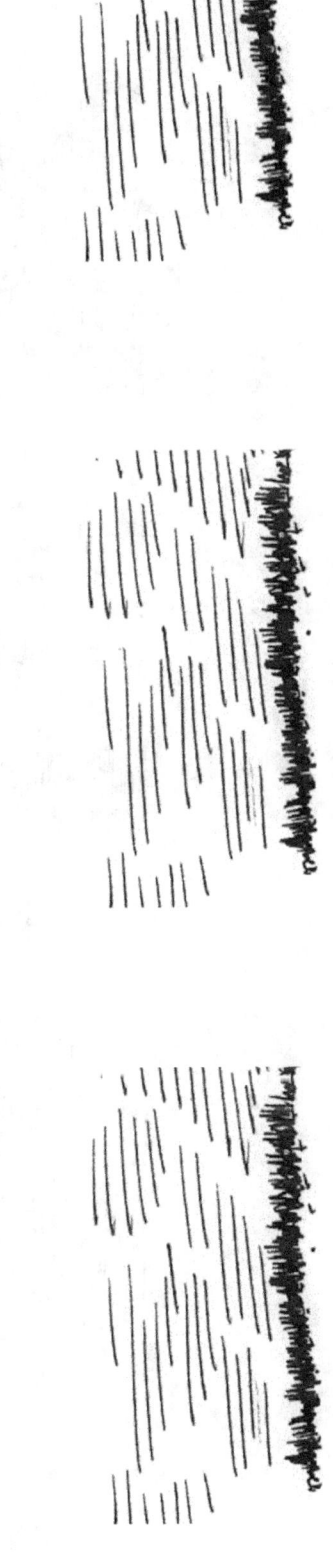

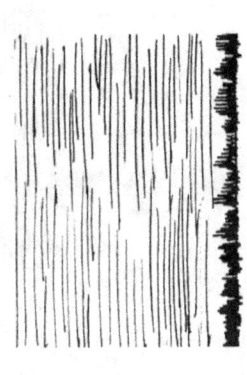

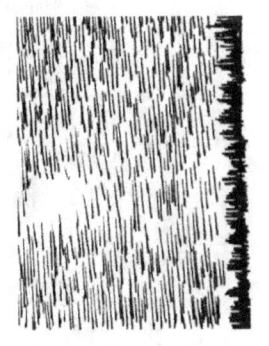

Drawing a Night Sky: Technique 3, Variations, Continued

A mix of shorter and longer parallel lines can be used to render night sky as well. This is done below. Indeed there is no limit to how such variations can be used to create a different feel for night sky. Try one now.

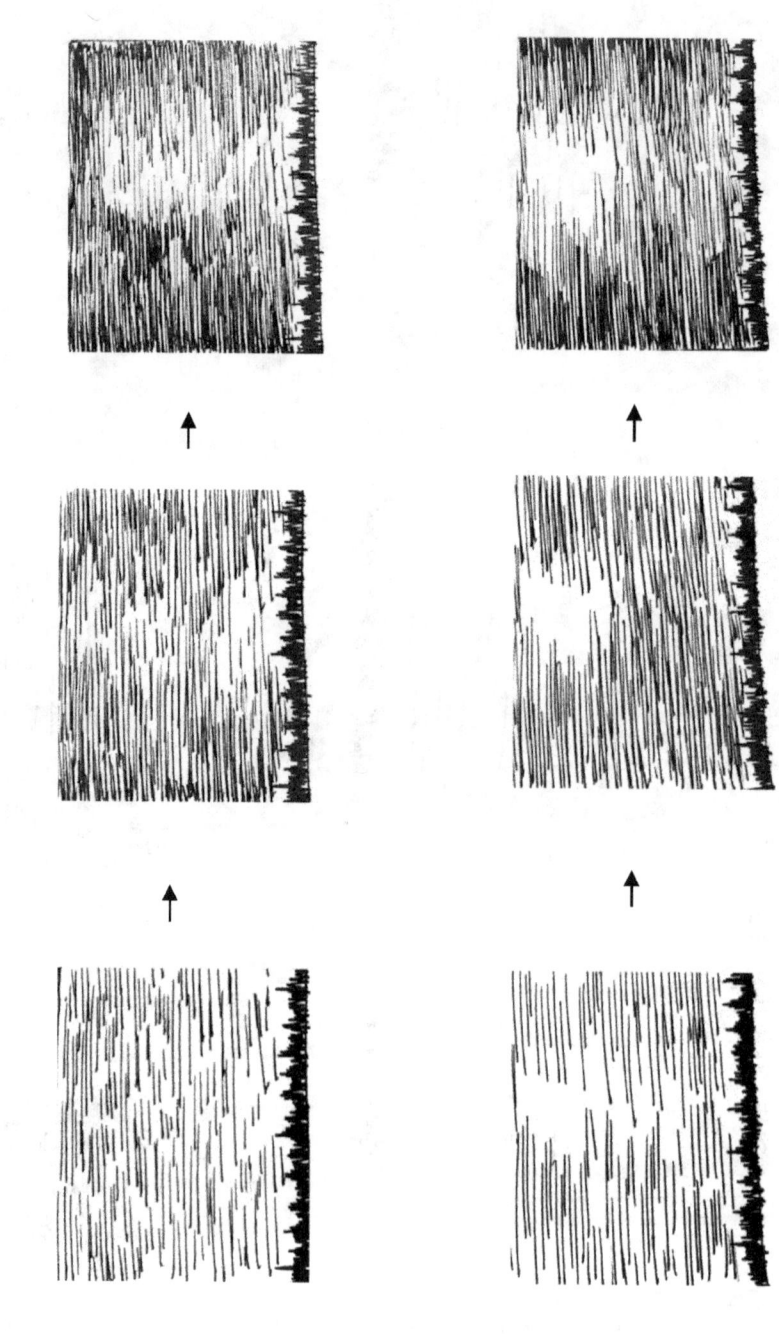

Drawing a Night Sky with Technique 3: Examples

Following are some drawings where technique 3 (horizontal parallel lines) are used to render night sky.

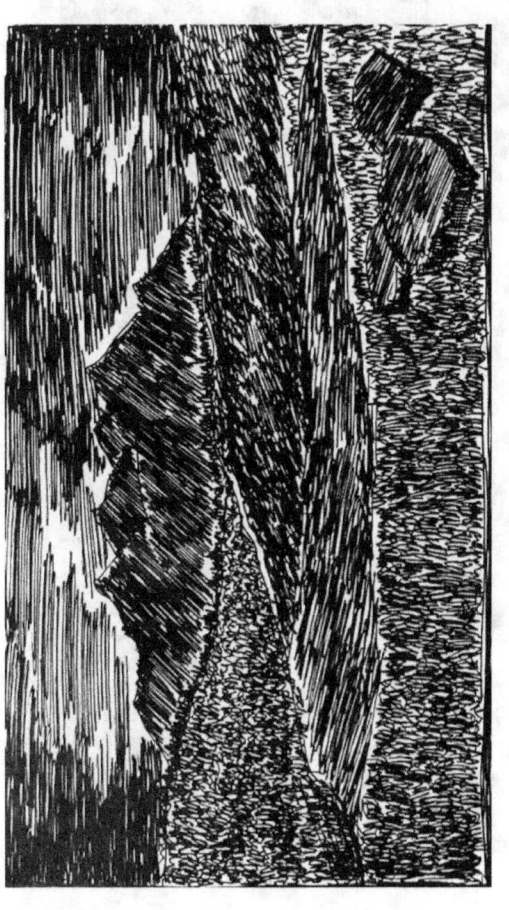

Earlier we saw different tonal variations patterns for night sky. With this technique, such patterns can be done easily.

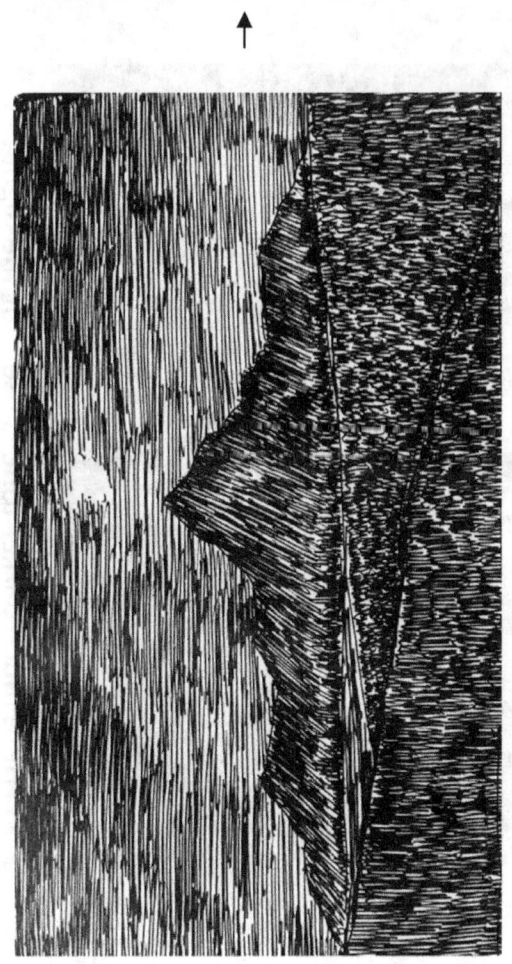

Leaving a streak of wavy light as in this drawing, gives more of a feel of late evening sky with dramatic feel.

Drawing a Night Sky with Technique 3: Yet More Examples

Study many examples presented in the workbook closely. These drawings illustrate the techniques that are discussed and with close study of these drawings, you will gain understanding of how to use these techniques in a drawing.

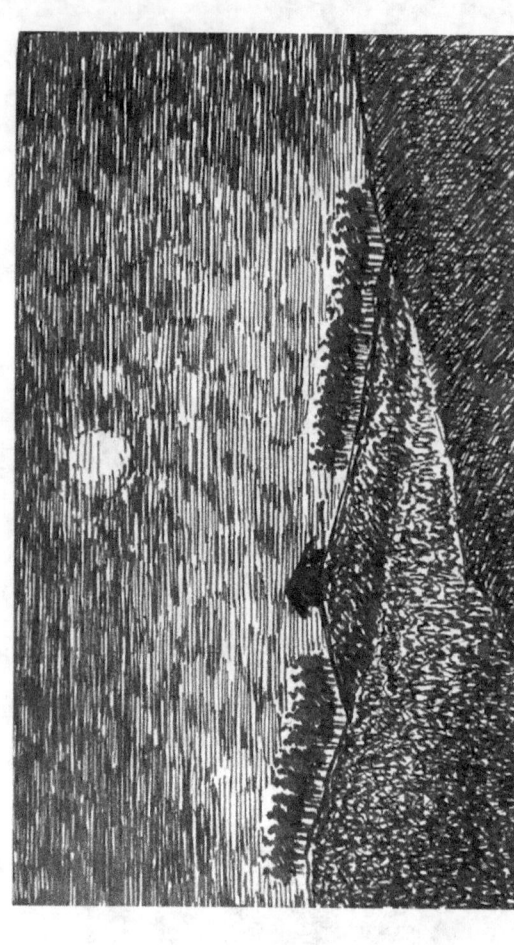

Shorter parallel lines are used here with moon partially covered. Compare this with one on last page to see the effect of use of different strokes for rendering sky.

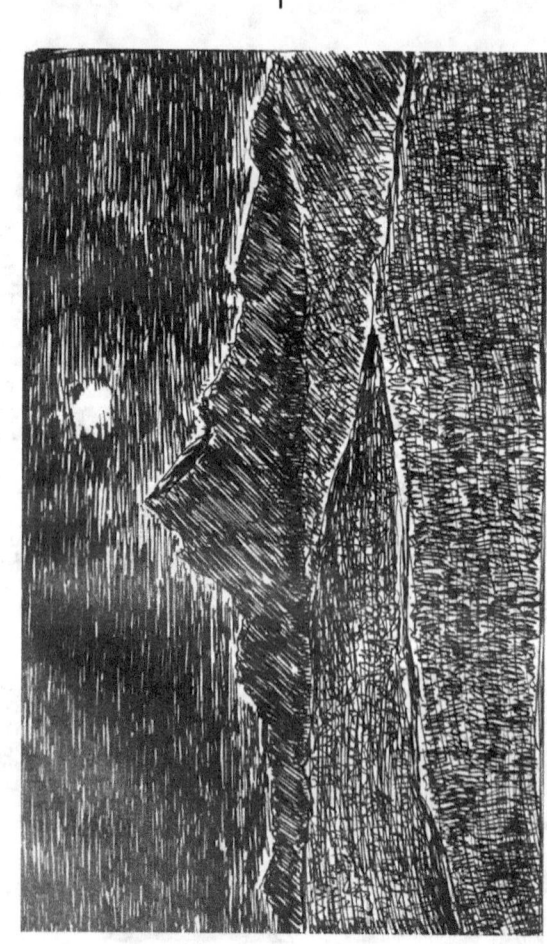

Here much darker tone is used for the night sky giving it a dramatic feel. Notice a streak of white along the mountain top. Such white helps to separate different elements and also adds to the effect.

Activity: Drawing a Night Sky with Technique 3

Finish the following drawing with steps as shown on last few pages.

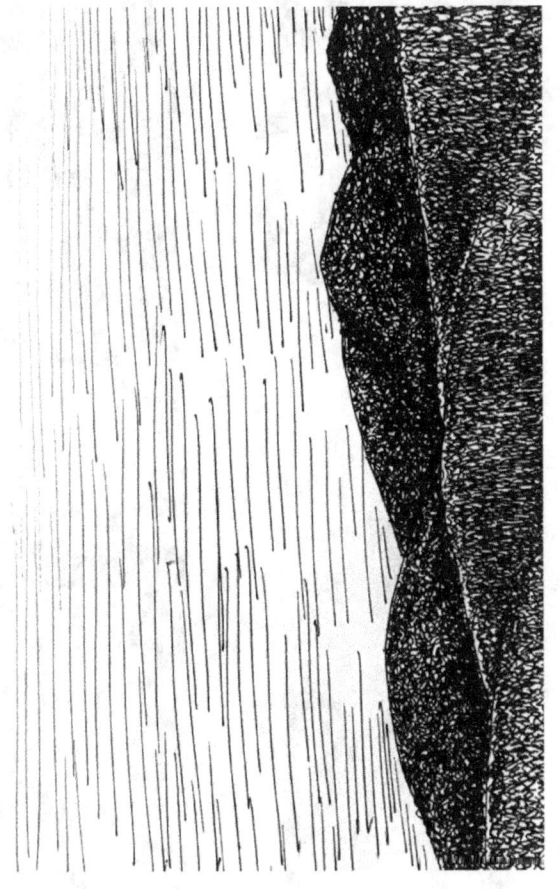

Drawing a Night Sky: Comparison of Technique 2 and Technique 3

This comparison between technique 2 and technique 3 shows how by changing the nature of line used, very different feel in the night sky is obtained. By further use of different variations in line use and tonal distribution discussed before, night sky with varied feel can be drawn. Try some now.

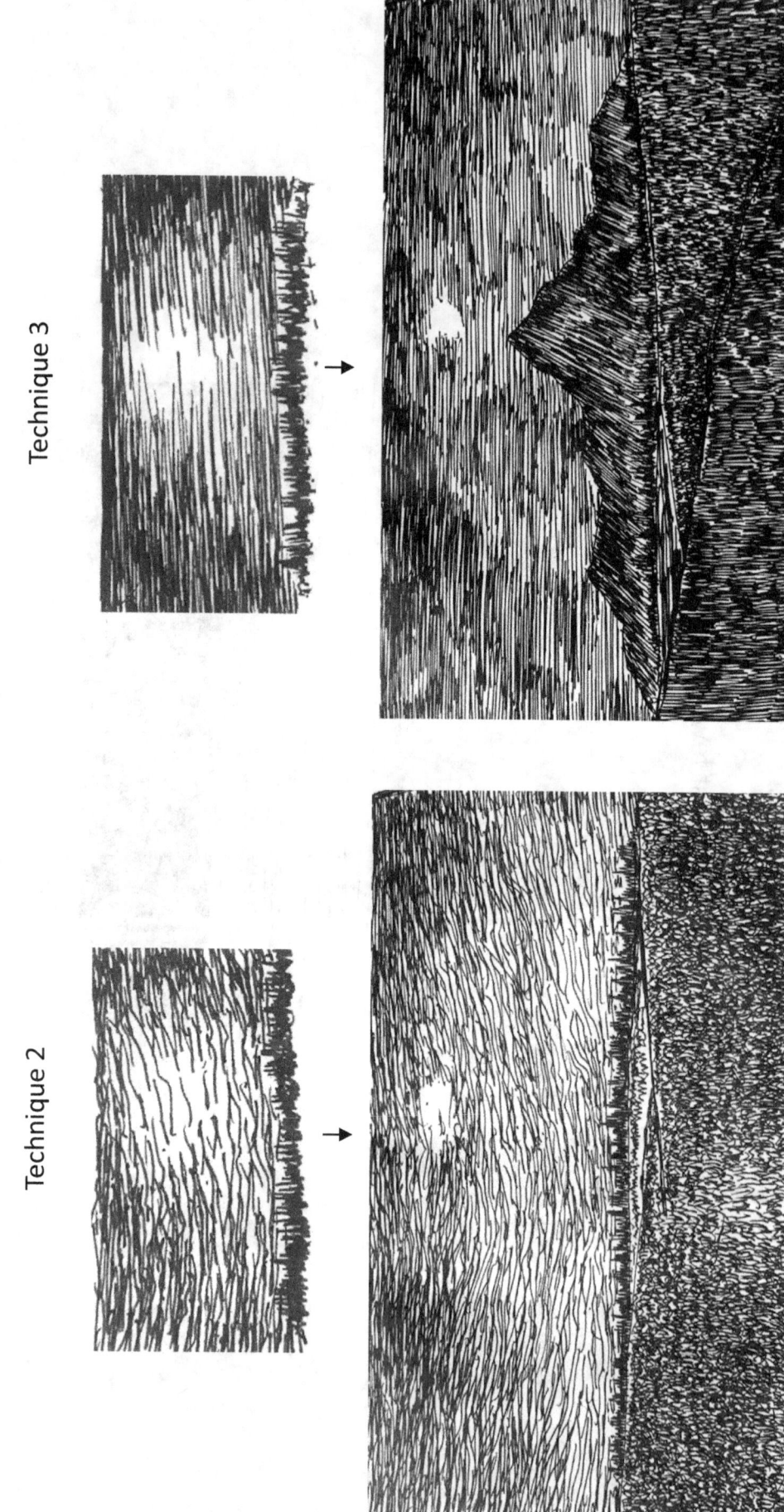

Drawing Night View of Mountains:

Drawing mountains in the background against a night sky is always very visually pleasing. Drawing mountains is discussed in detail in **vol 4. of the workbook series**. You can find more information on the workbooks at **www.pendrawings.me/workbooks**. To depict a mountain in night sky, its tones has to be darkened. This is done by using vertical parallel lines as shown below.

Using vertical parallel lines, tone is added to the mountain.

At night, mountains have darker tone and this is achieved by using vertical parallel lines to make them darker. Use multiple layers of parallel lines to add more tone. Adjust the tone based on the feel you want to evoke.

Drawing Night View of Mountains: Another Example

Here is another example. Tone is again added using vertical parallel lines. Different ways to draw mountains are covered in detail in vol. 4 of the workbook series.

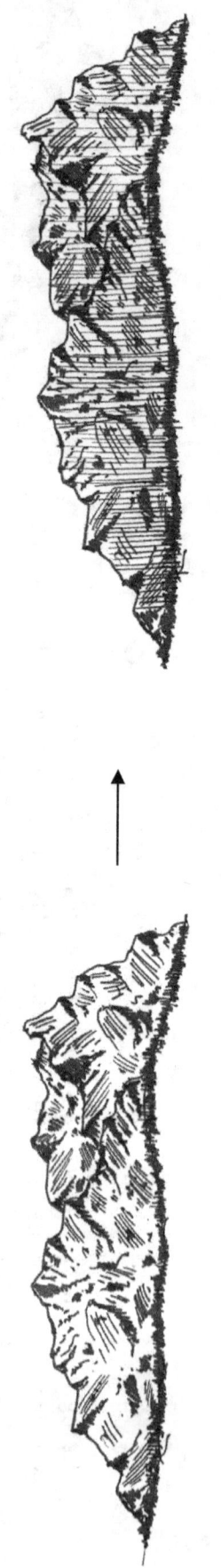

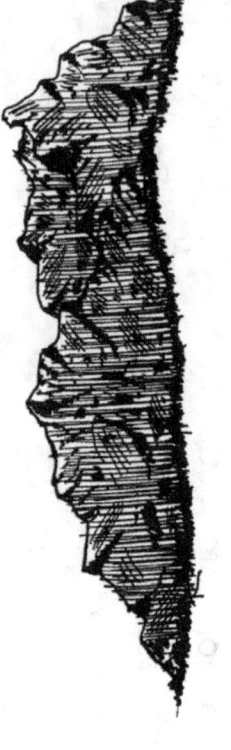

Being able to draw such parallel lines, especially longer ones, is difficult in the beginning. For tips on how to practice drawing them, pl. visit www.pendrawings.me/parallel_lines

Activity: Drawing a Night View of Mountains

Use parallel lines to increase tone and give the following mountains a feel of night as shown earlier.

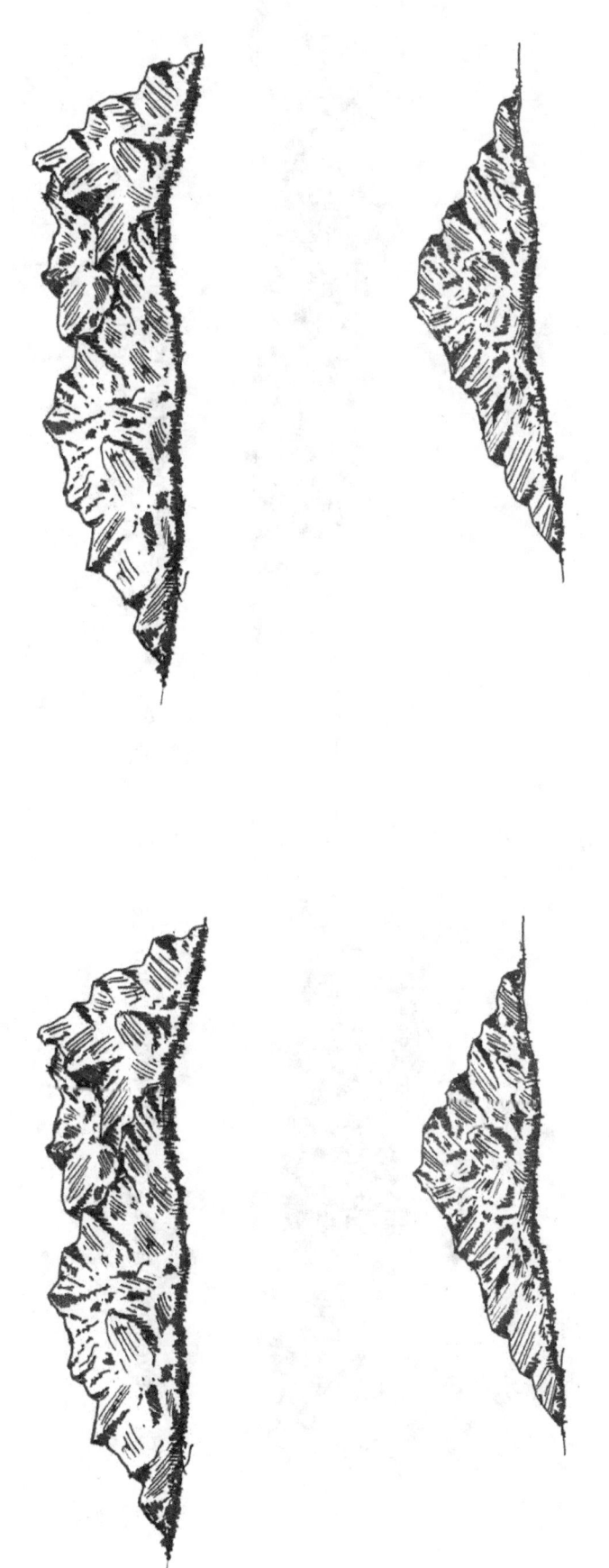

Level of Darker Tone:

Level of darker tone used to depict a mountain at night should commensurate with the tone of night sky depicted against which the mountain is set. Lighter tone for mountains can be used when sky is shown lit with moonlight where as a dark night sky will need more dark mountains to indicate lack of night light. Use more lines to add more tone in this case.

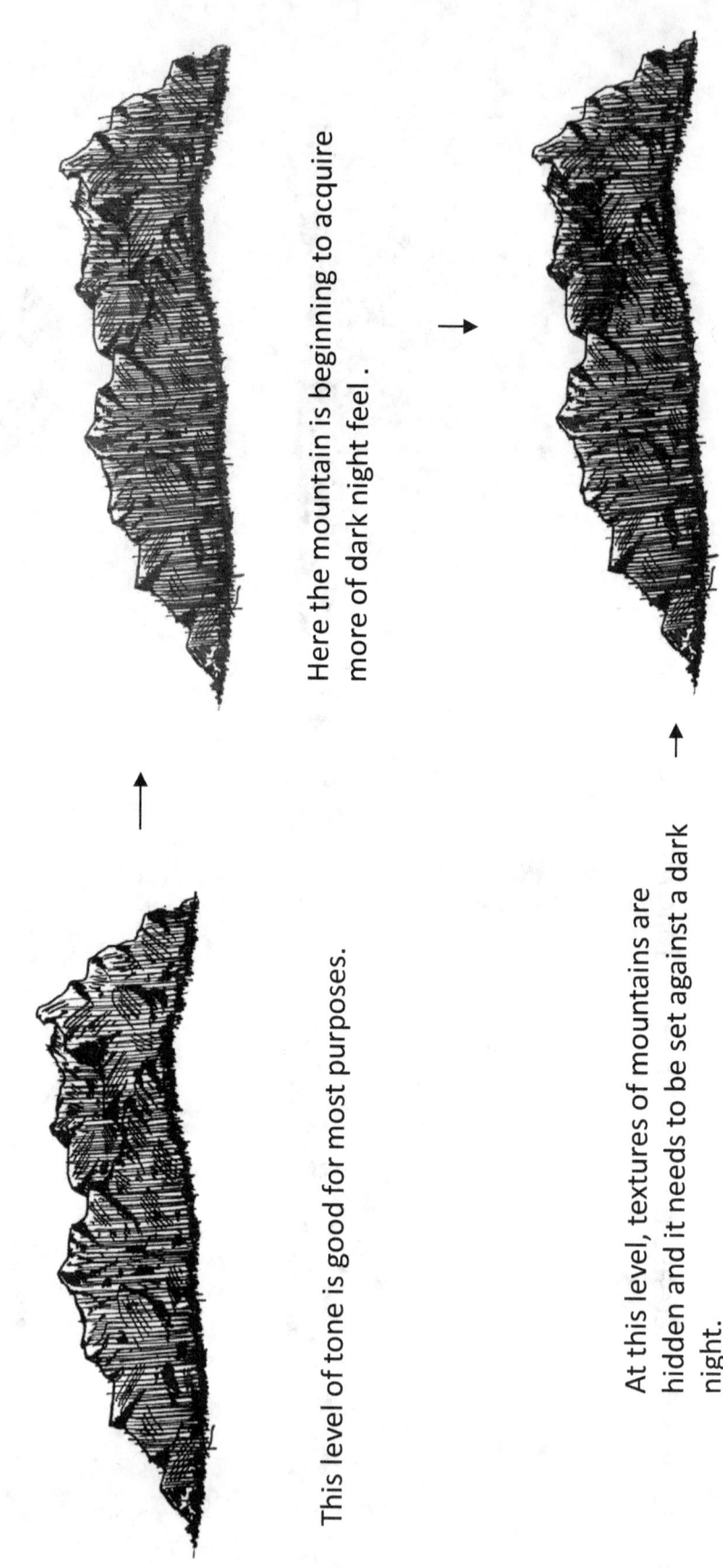

This level of tone is good for most purposes.

Here the mountain is beginning to acquire more of dark night feel.

At this level, textures of mountains are hidden and it needs to be set against a dark night.

Drawing a Night View of Mountains: Examples

Here are some drawings incorporating mountains. The tone of mountains can be adjusted to give it intended effect. Darker tone for mountain will give more intense and foreboding feeling where as lighter tone will help to lighten up the sky. The tone of sky should also be in accordance with the tone of mountains. In a very dark sky, lighter tone for mountains will look odd. Notice also how different stroke used for sky gives different feel to the mountains.

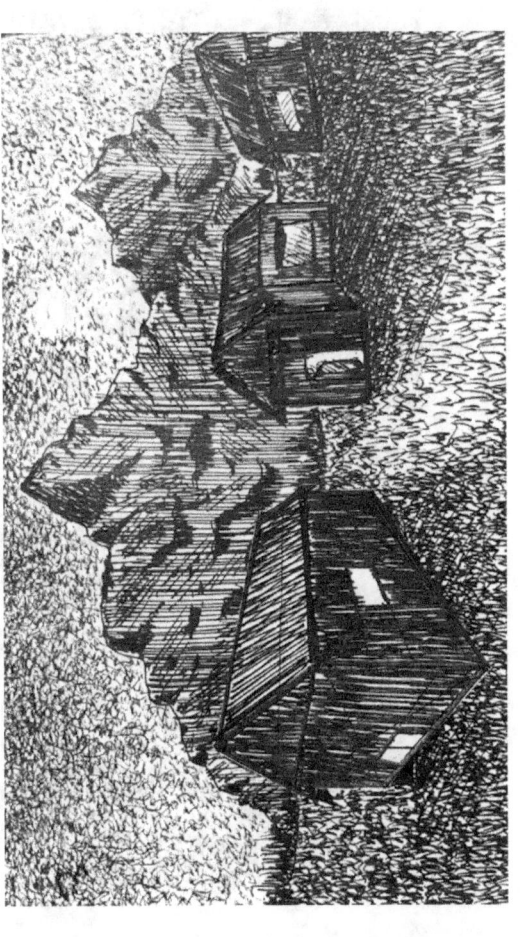

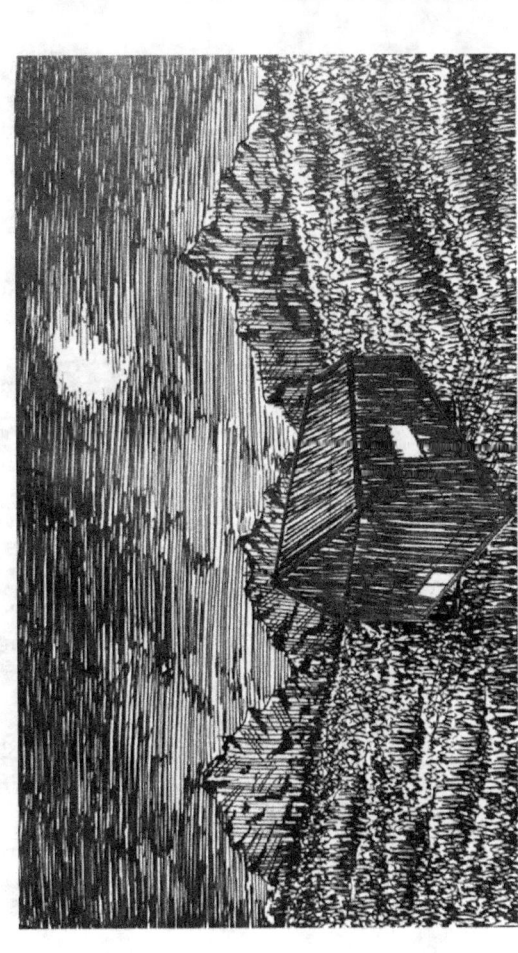

To keep more focus on foreground, keep the distant mountains small. A big looming mountain, like in the second drawing, draws attention to itself and becomes a key focal point.

Drawing a Night View of Mountains: More Examples

Here are some more examples of mountains that we saw before. Different sizes and textures for mountains also helps to give them different feel at night. Mountains with rounded edges tends to calm the scene where as mountains with sharp angles tends to do the opposite.

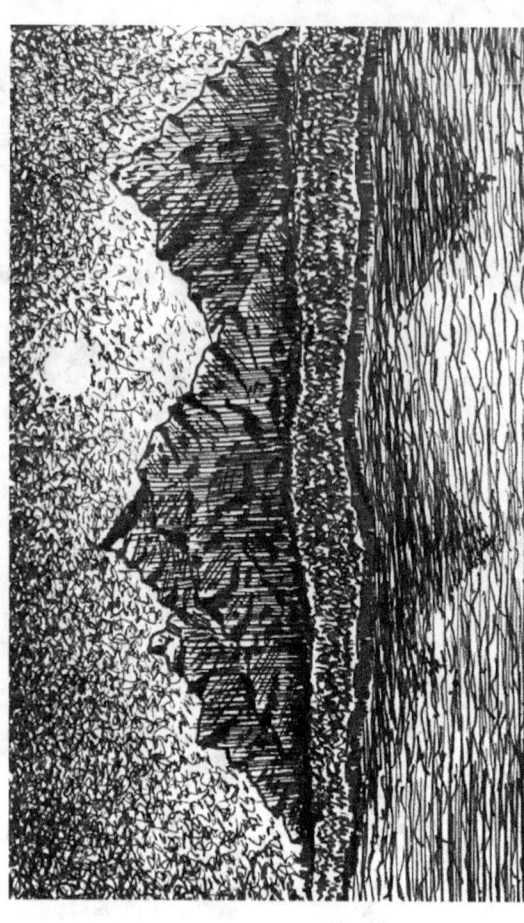

Here Mountains are main focus of interest and hence drawn bigger with darker tone to set the mood.

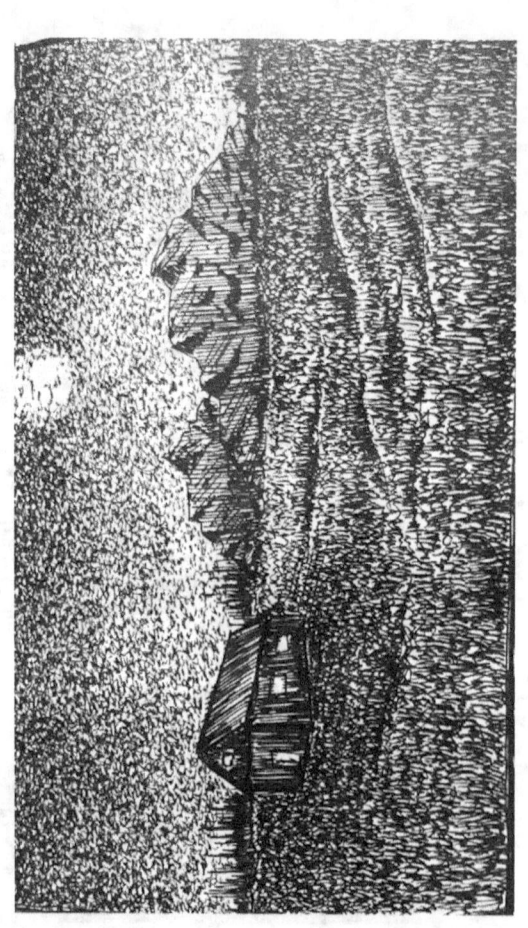

In this drawing, house is also focus of interest and hence mountains are drawn at smaller scale and left relatively lighter.

Alternate Approach to Drawing Night View of Mountains:

In last few pages we saw how properly textured mountains can be darkened using vertical parallel lines to give a feel of night. An alternate approach is to simply darken the mountain outline using angular parallel lines as shown below. This doesn't show much texture on the mountains, but can be sufficient in many cases.

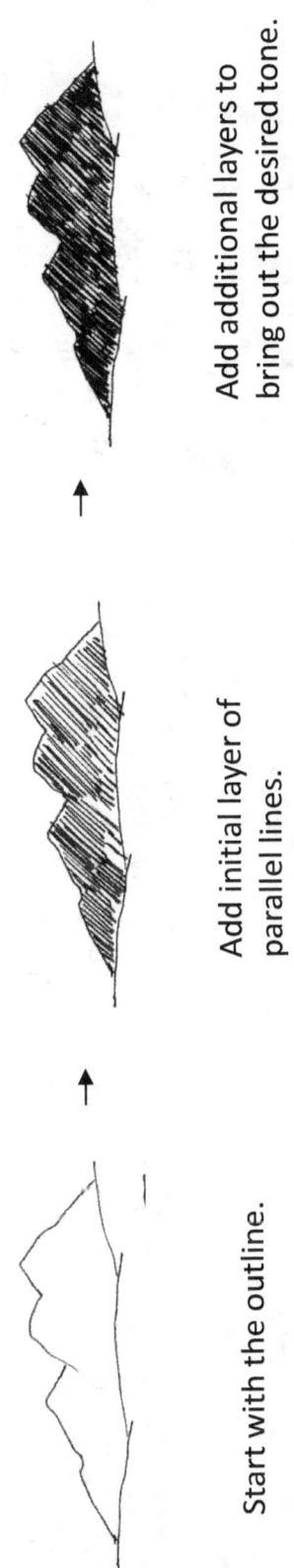

Start with the outline.

Add initial layer of parallel lines.

Add additional layers to bring out the desired tone.

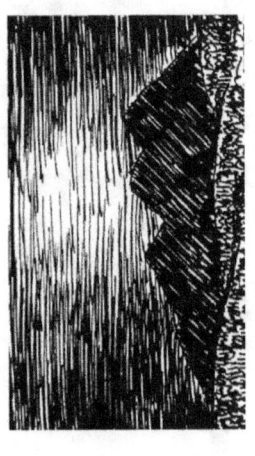

This technique is especially useful when drawing at a smaller scale. It doesn't give much texture to the mountains but more of a silhouette but is quite effective in many settings, especially at smaller sizes. For drawings at bigger sizes, more details in the mountains should be visible and here earlier technique for drawing night mountains is more appropriate.

Application of Overlapping Parallel Strokes:

The angular parallel strokes should be applied in an irregular overlapping manner as shown below. This creates irregular bands of darks that give sense of texture and depth to the mountain.

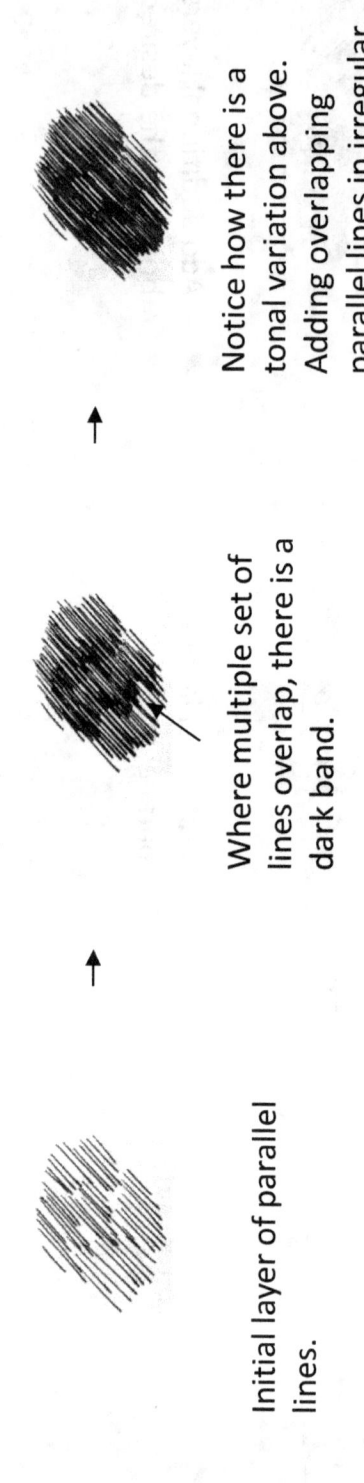

Initial layer of parallel lines.

Where multiple set of lines overlap, there is a dark band.

Notice how there is a tonal variation above. Adding overlapping parallel lines in irregular manner with result in such tonal variation. This adds to perception of depth. Strive for this in your drawing.

Activity: Alternate Approach to Drawing Night View of Mountains:

In the following outlines, use parallel lines to add tone and give a feel of night sky as shown earlier. Draw some more of your own.

Drawing a Mountain Range:

A mountain range can be drawn using the same technique. A range is often more visually appealing. Make the successive mountains in the back smaller and darken their bottom. This is discussed in detail in vol. 4 of the workbook that focuses on draw mountains in detail. For more information, pl. visit www.pendrawings.me/vol4

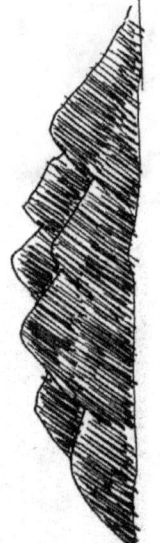

Add additional layers as described in last page to build up tone.

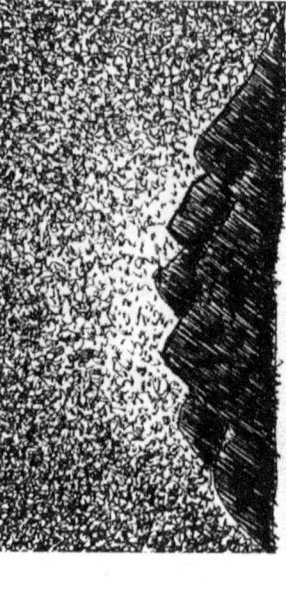

Finish with Sky and other elements.

Use initial layer of parallel lines to add tone.

Start by drawing the outline.

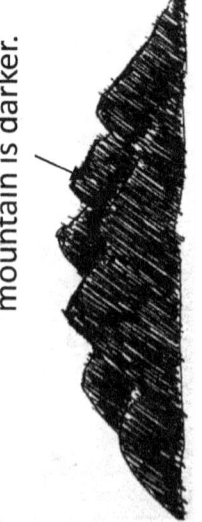

Bottom of behind mountain is darker.

Darken them to your liking.

Alternate Approach to Drawing Night View of Mountains: Examples

Following are some examples of drawings using the technique discussed previously for drawing mountains. This technique works for mountains drawn till this size. Any bigger mountains should be drawn with more details using earlier technique.

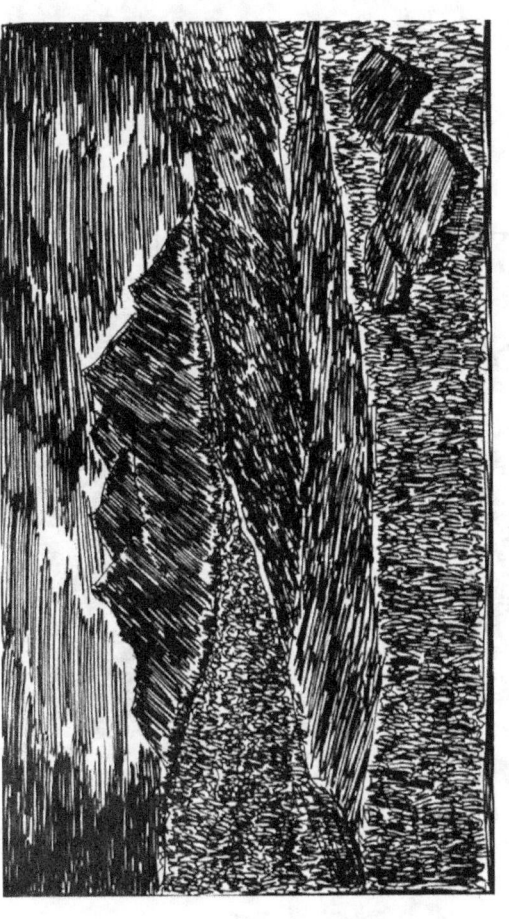

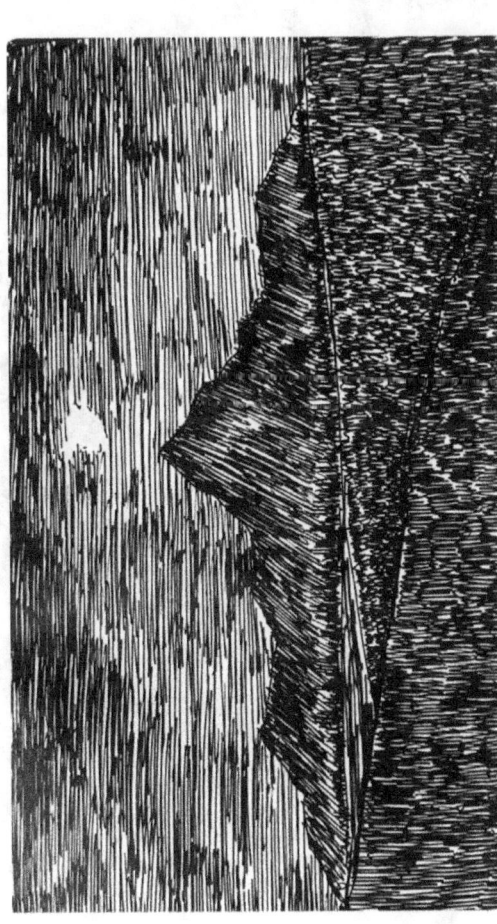

Notice that there is some tonal variations in the body of the mountains. Some areas are darkened more and others left lighter. This helps to give more form and depth to the mountains. A uniform dark tone will give it flat appearance.

Drawing a Night View of Ground with Grass Stroke:

Most landscapes have ground and being able to draw a night representation of ground is necessary for drawing night landscapes. Drawing ground cover is discussed in detail in other volumes in the workbook series. To give a feel for night, more strokes are added to giver it darker tone and give a feel of night.

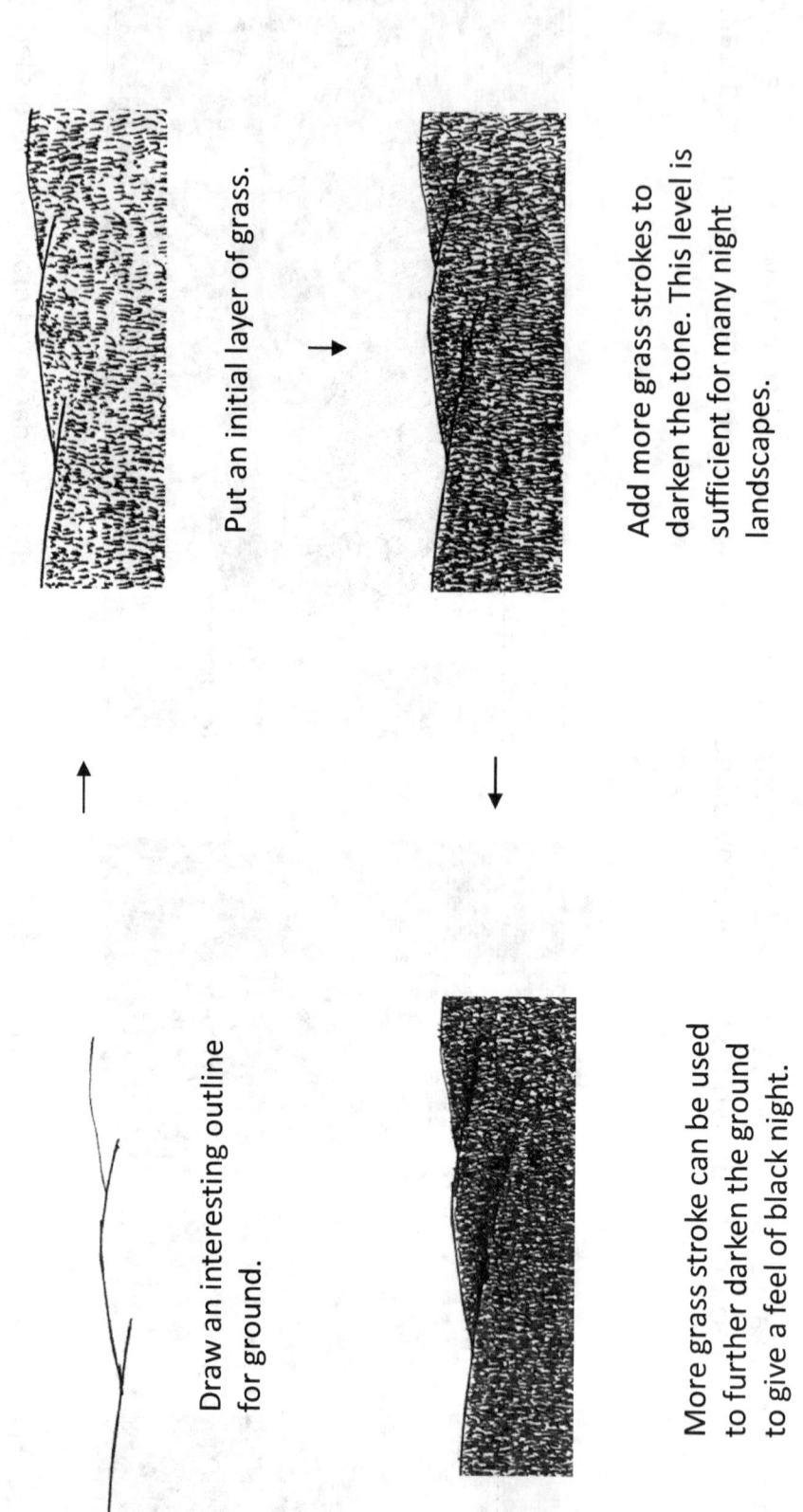

Draw an interesting outline for ground.

Put an initial layer of grass.

Add more grass strokes to darken the tone. This level is sufficient for many night landscapes.

More grass stroke can be used to further darken the ground to give a feel of black night.

Activity: Drawing a Night View of Ground:

Draw night view of ground as shown on previous page below.

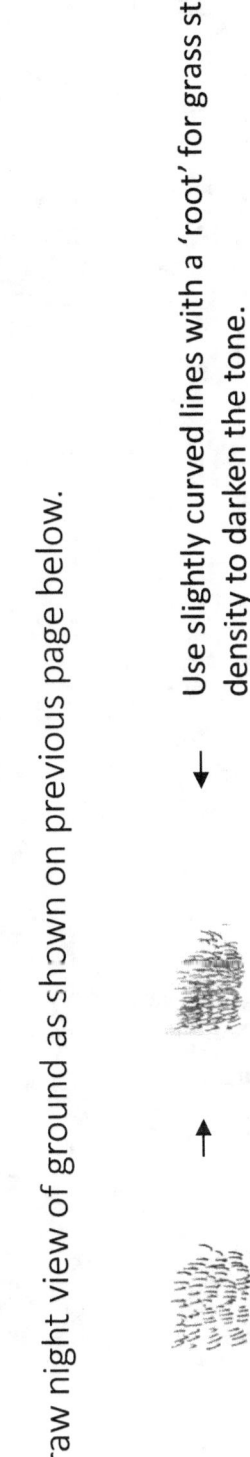

→ Use slightly curved lines with a 'root' for grass stroke. Use more density to darken the tone.

Drawing a Night View of Ground Using Scribble:

Another stroke and technique to use to give dark texture to ground is by using scribble stroke. As shown below, this stroke gives a nice dark tone and is very effective at conveying a sense of night ground. It is also very easy to use and can be done very quickly.

Scribble stroke like this can be used to texture ground as well. Add successive layers to darken as needed.

Add initial layer of scribble stroke.

Add more stroke to darken and bring out the desired feel for night.

Start with the outline.

Activity: Drawing a Night View of Ground with Scribble Stroke:

Draw night view of ground as shown on previous page below. Try some of your own.

Giving Depth to Ground:

When using interesting intersecting ground plain lines as below, it is important to have some tonal variation as shown below. Otherwise the ground will appear flat and look odd. Drawing such interesting ground plains is discussed in detail in vol. 6 of workbook series.

Start with intersecting plain lines as shown above.

A uniform tone of grass stroke is used to texture ground. Notice how the ground appears flat in absence of tonal variation.

The area around the lines should be darkened a bit more to indicate that it receives less light due to the curvature of the ground. The ground now has a form due to tonal variations.

The overall tone of ground is darker here but still there is tonal difference with areas around plain lines darker. Always create such tonal variations on the ground to bring out its form when using interesting ground plain lines. Study other examples in the workbook to learn further.

From Evening to Night:

In the following series of drawings, successively more tone is added to the sky to go from an evening setting (with comparatively brighter sky) to a night setting with darker tones. The key to understand is that any desired mood between early evening to dark night can be set by such use of appropriate tones. Again, extensively practice doing tone control to be able to draw appropriate settings based on your composition.

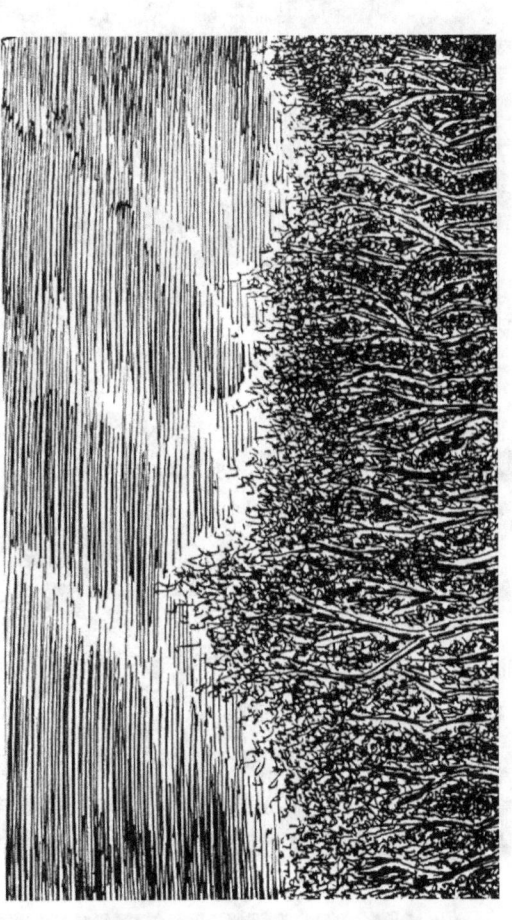

Single layer of parallel lines here gives a feel of early evening sky with lower level of tone.

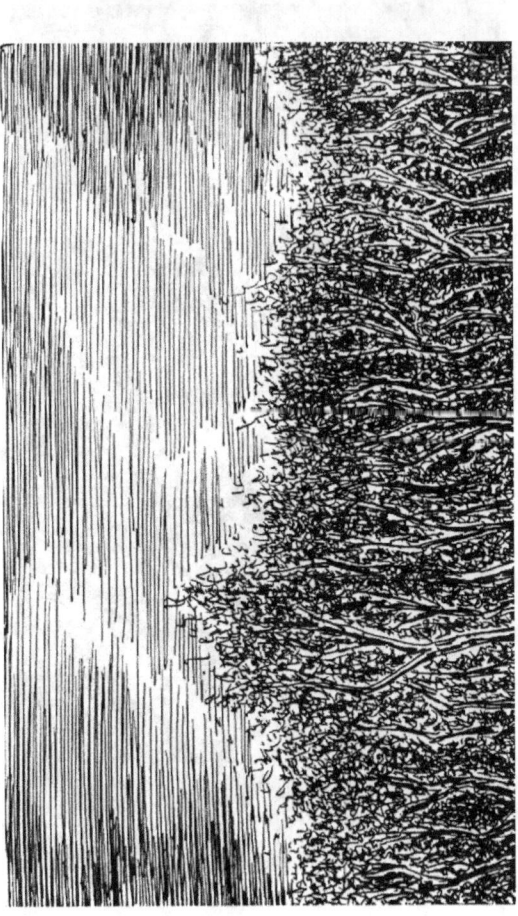

Another layer of parallel lines is added to darken the tone giving a feel of late evening sky.

From Evening to Night, Continued:

Notice how by adding additional tones with more use of stroke, different feel for Sky can be obtained. This is true for all different types of strokes we have seen so far for rendering Sky. Try doing such tonal control exercises.

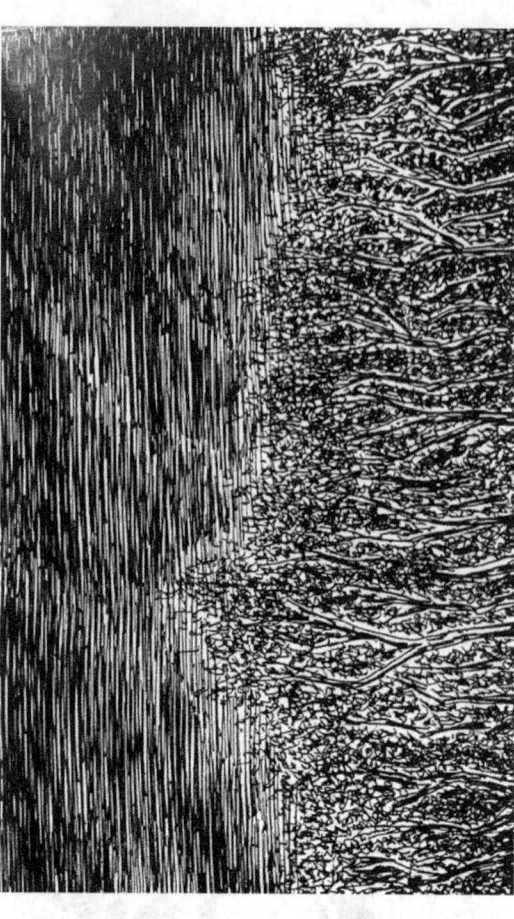

With much darker sky tones, it is now firmly a night setting.

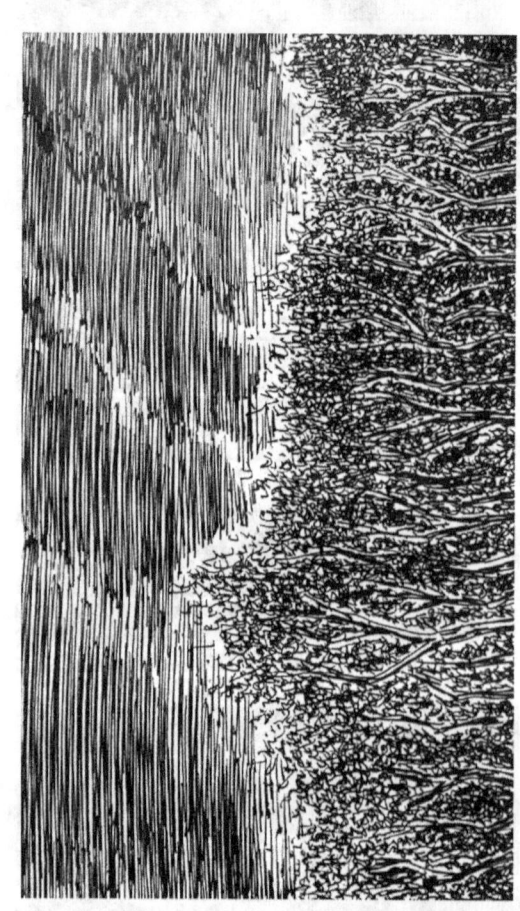

Another layer of parallel lines is added here to go from late evening to early night sky.

Composition Themes for Nightscapes:

So far we looked at how different elements can be textured to give indication of night. We will next look at how different elements can be combined and used to create a night scene. There are indeed limitless ways of doing such night landscapes. My hope is that in next few pages you will get inspiration and ideas to get you started. After studying and practicing them, try some of your own ideas.

A simple night landscape essentially consists of night sky, a distant tree line and ground reflecting the darkness of night. Even in this simple composition, by using different techniques for night sky, different tonal variations and interesting shapes for ground, very pleasing night landscapes can be drawn. Following are some examples.

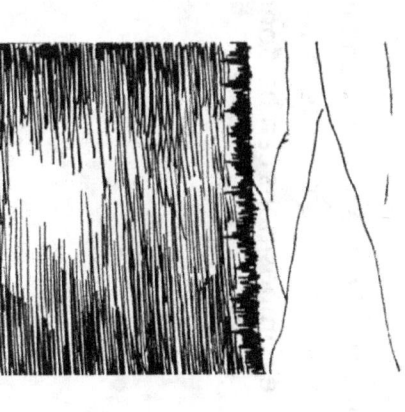

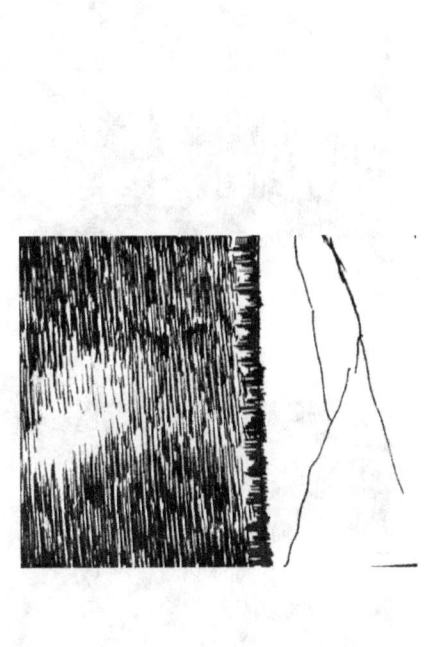

These 2 drawings were earlier seen on page 40 when discussing different tonal variations in the sky. We now extend it by adding a ground. Outline for ground form is initially drawn. Use interesting intersecting lines for ground as discussed before.

Composition Themes for Nightscapes:

We continue with the drawings on last page by using grass stroke to texture the ground.

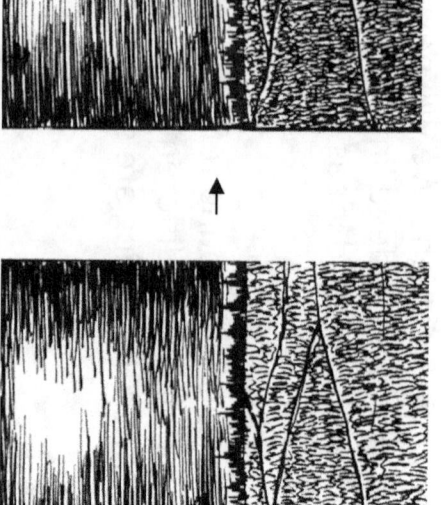

Darken the ground more near ground lines as discussed before to bring out the form of ground. These simple compositions can be done from imagination anytime.

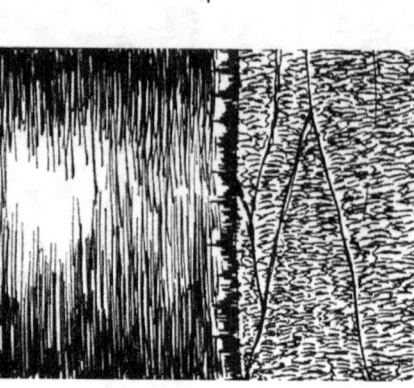

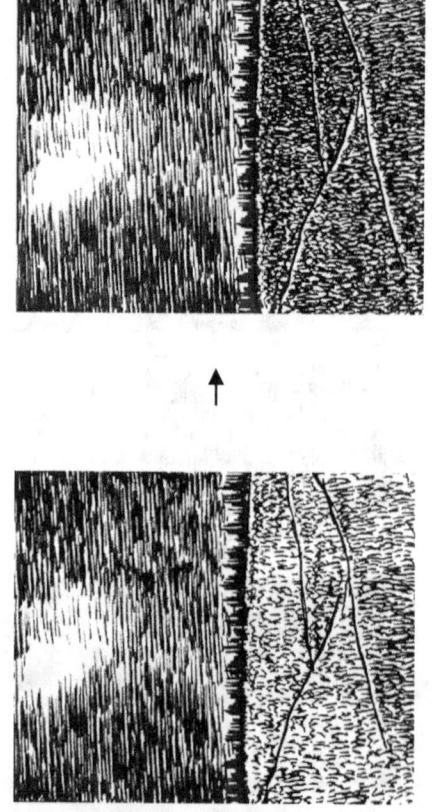

Use more grass stroke to add more tone. In the first drawing, the grass is not sufficiently dark enough to give feel of night sky. Darkening it with another layer brings out the night effect.

Tonal Variation on the Ground:

As we saw before, there has to be a minimum level of ground darkening to bring out the feel of night. But the ground can always be darkened further to give more intense feel. There should be a balance between level of darkening sky and ground though. If the sky is darkened lightly, then ground should also be left lighter as light from Moon and other reflected light will lit the ground.

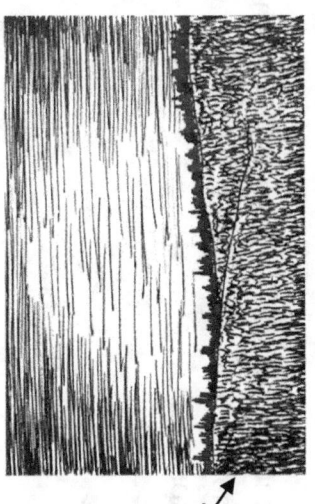

Lighter in center with edges darker.

In this drawing, sky is significantly lighter in the center area and this should be reflected in the tone of the ground cover. Tonal variation on ground should follow the variation in the sky. A very dark ground would look odd here.

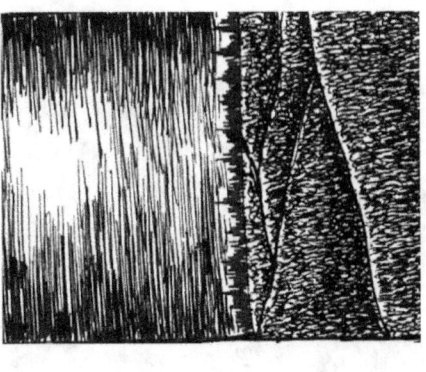

The level of ground darkness can be little less (as there is significant streak of white in the sky) but it doesn't look overtly odd.

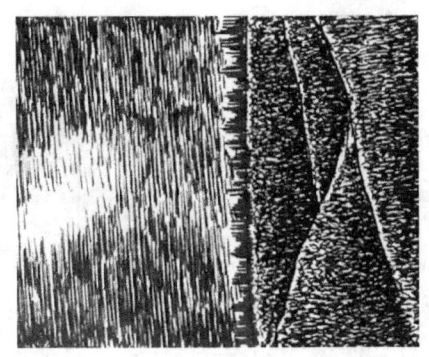

Composition Theme: Amount of Ground Cover:

Another design decision is the proportion of drawing space given to ground vs the sky. In the simple composition with no other foreground elements, it is usually visually more interesting to make Sky the focus of attention. In this case, around 20 to 30% of vertical space should be given to ground and remaining for Sky. Of course there is no hard and fast rule around it. Experiment with different combinations to see what you prefer.

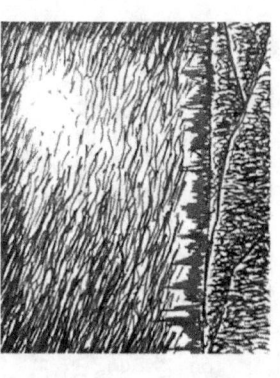

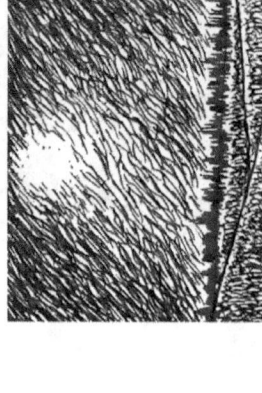

Here ground is barely present and the focus in firmly on sky.

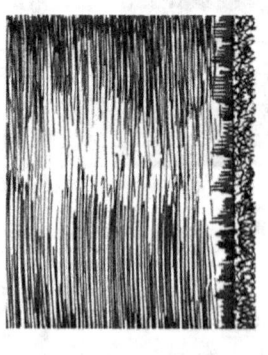

Here ground gives a pleasing appearance while not dominating. This is usually good for many compositions.

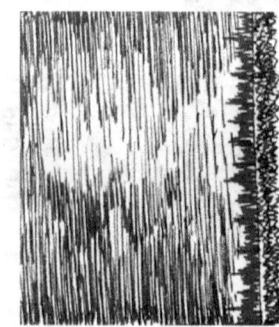

Here the ground cover same amount as Sky and hence also demands equal visual time. In this case make the ground interesting with different plain lines as is done here or better yet add other foreground elements to give it more visual interest. A simple ground here would make this drawing un inviting. Key is to give drawing area to elements that is proportional to the visual interest you think they will induce in the viewer.

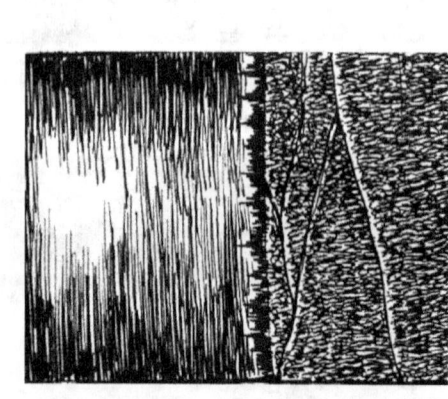

Composition Themes: Adding Mountains

Next step in building the composition is to add an element in the background. A mountain or hills work very well. We discussed in detail earlier how to depict a mountain in night sky. Below, mountains are added to the drawings in the previous page.

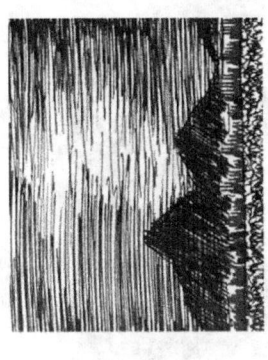
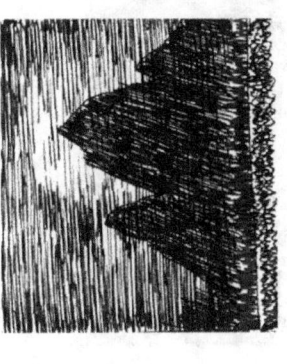
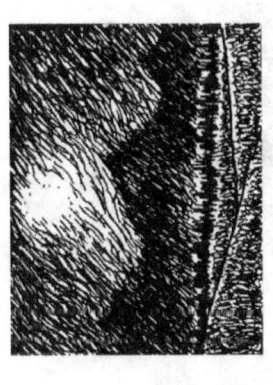
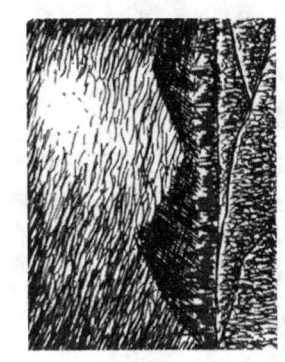

This is a very simple composition theme consisting of ground, mountains, distant tree line and sky. But as you can see above, by varying the strokes, tones and forms of these elements, nightscapes with very different feel can be drawn based on this simple theme.

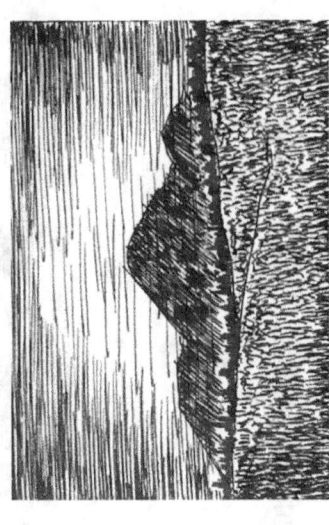

Compared to drawings above, mountain here is textured on a lighter side due to lightly textured sky. Sky, mountain and ground tone should be in accordance with each other to bring out the right feel.

Composition Themes: Adding Mountains, More Examples

Here are some more examples of mountains in a night scene. Some of these we saw before when discussing drawing mountains.

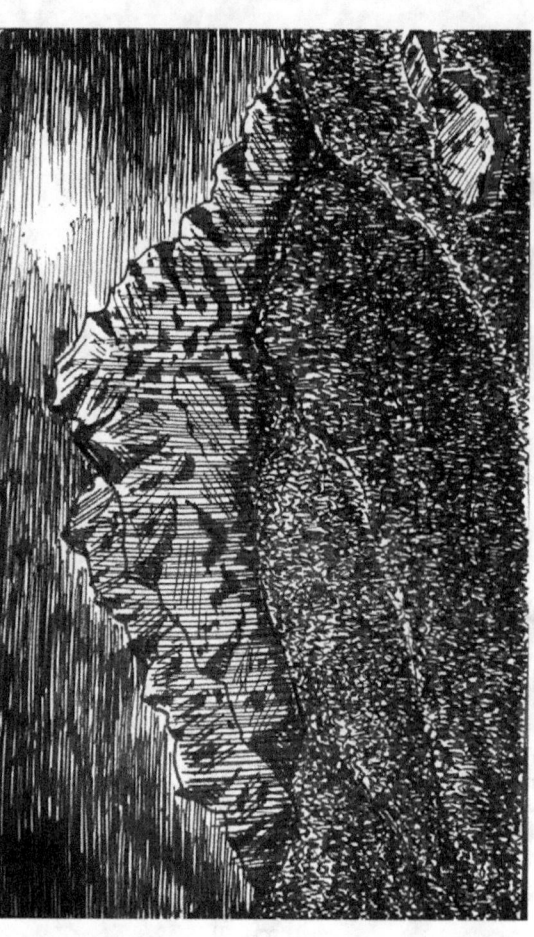

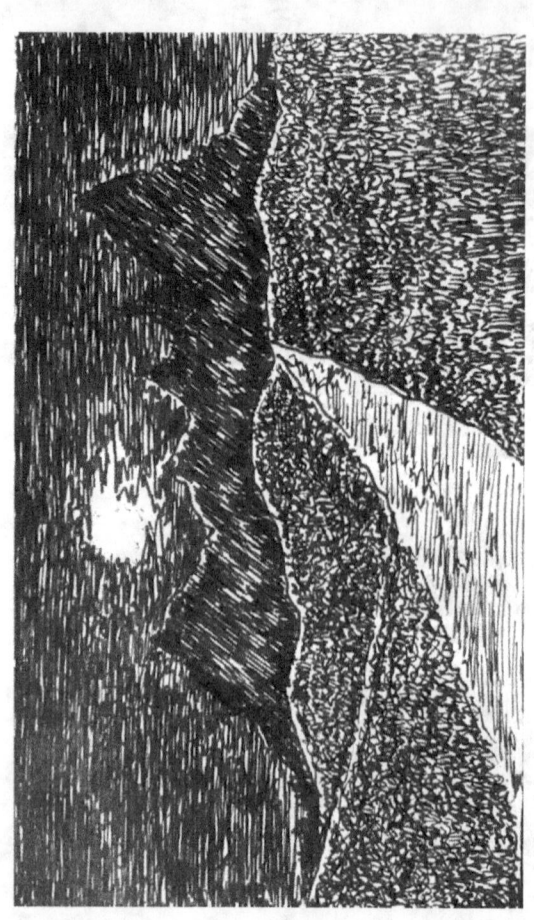

Composition Themes: Adding Hills

Just as mountains, hills are also a great background element for a nightscape. There are many ways to texture them and they have been covered extensively in vol. 6 of the workbook series. For a nightscape, they need to be textured dark and one simple technique to use is a scribble stroke as shown below.

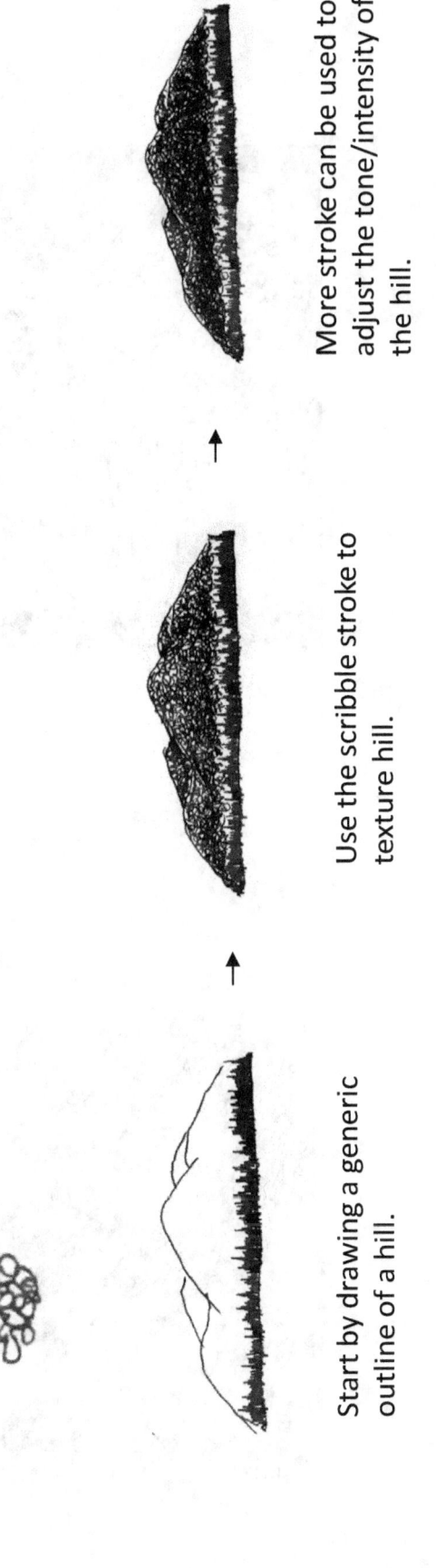

Scribble Stroke: This can be used to texture a night hill.

Start by drawing a generic outline of a hill.

Use the scribble stroke to texture hill.

More stroke can be used to adjust the tone/intensity of the hill.

Composition Themes: Examples with Hills

Following are some drawings we saw earlier where a hill has been added. A dark hill provides a nice contrast and focal point in a night sky. Following drawings consisting of a tree line, a hill and a night sky are quick pleasing drawings that can be attempted in your breaks. By using different strokes and tonal variations for sky and shape and size for hills, many pleasing drawings on this theme can be done.

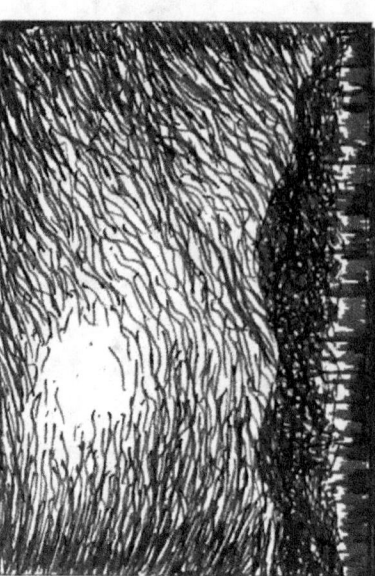

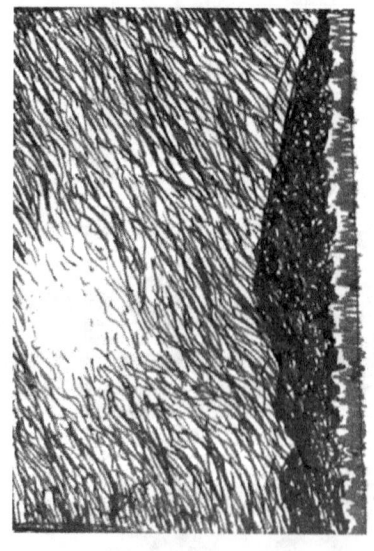

Composition Themes: Close up of Hills

For showing something on a hill, like a house or any other structure, the hills need to be drawn closer up. In this composition, ground is omitted but the presence of a house, church or any other element on top of hill gives a very pleasing feel against a night sky.

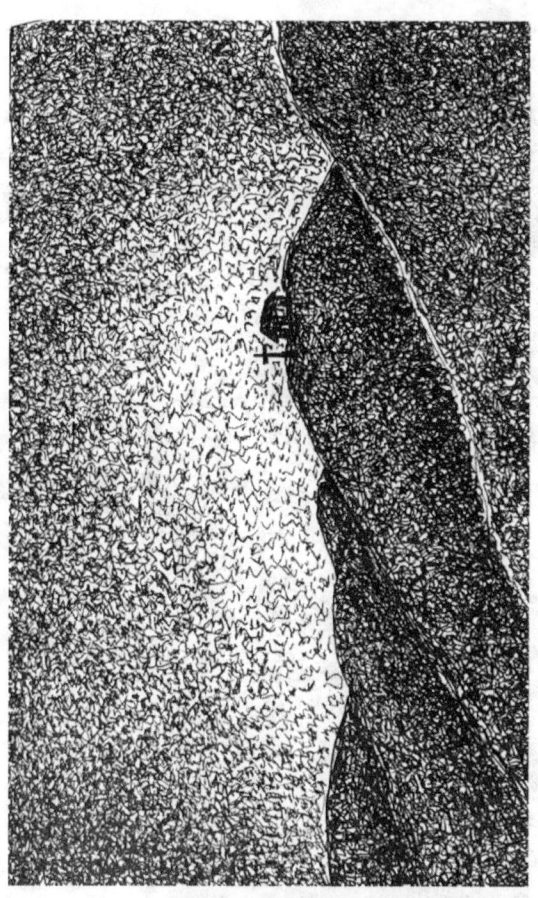

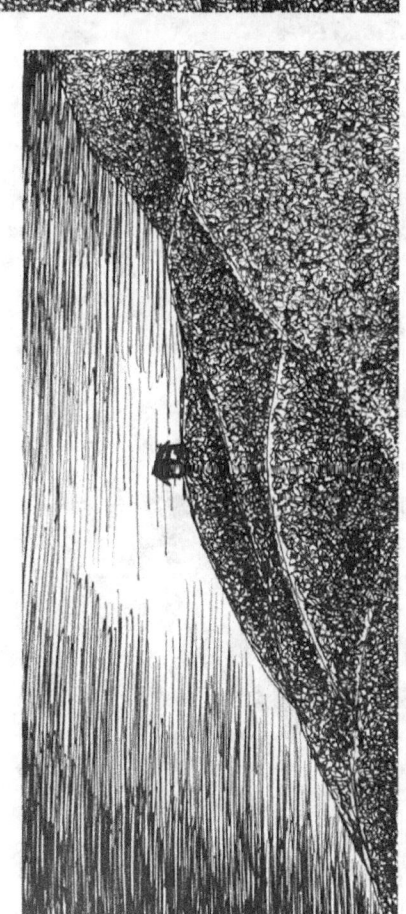

Without a ground, the focus is on the hills. Make them interesting using different shapes and overlaps as done here. Another focal point on top of hill, like a house here adds to visual interest.

Notice the different effect that use of different sky stroke has on the overall feel. Dots and small ticks gives a feel of stillness and quite that works well with a church on hill top in this drawing.

Composition Themes: Close up of Mountains

Similarly, Mountains can be drawn close up without a ground. In this case, more textures on mountains need to be indicated as they are more visible. Draw a focal point around the top pf mountains to add visual interest just as with hills.

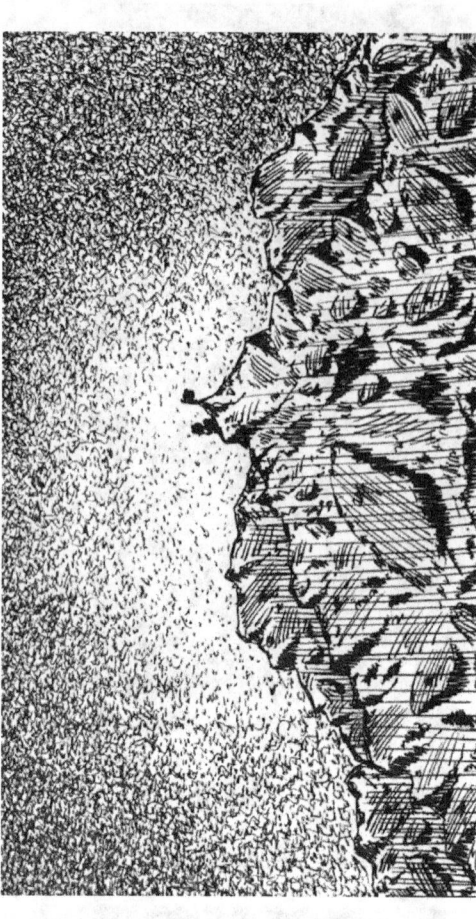

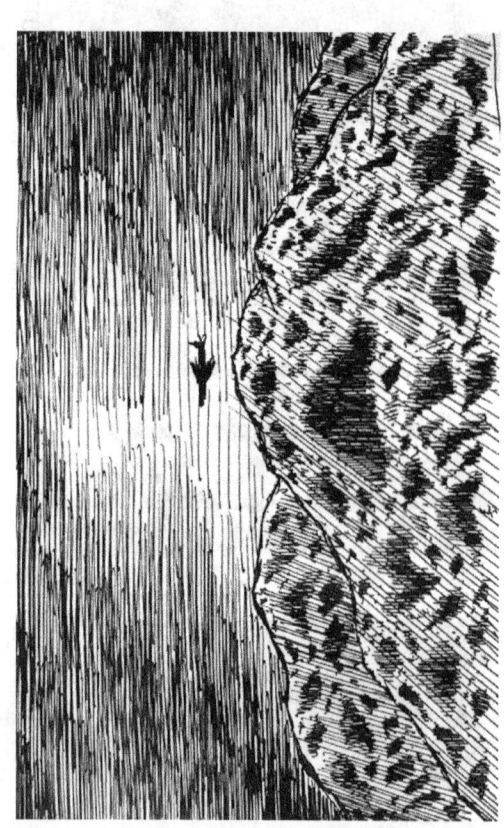

A plane flying across a night sky is captured in this drawing using a close up of mountains.

Close up of mountains here shows a boy sitting on the top. As you can see, in these drawings, by omitting ground, things on mountains can be brought more into attention by close up of mountains.

These close up compositions provides a very different feel compared to when these same elements are used with ground as we have seen earlier. Bringing different elements closer or moving them further in your compositions can create different feel to them. Try these different compositions.

Composition Themes: Adding Foreground Trees

So far we have looked at compositions involving sky, ground and a background element. Next step is to add more interesting foreground elements. Trees are a great addition as foreground elements and adds very pleasing feel to the drawings.

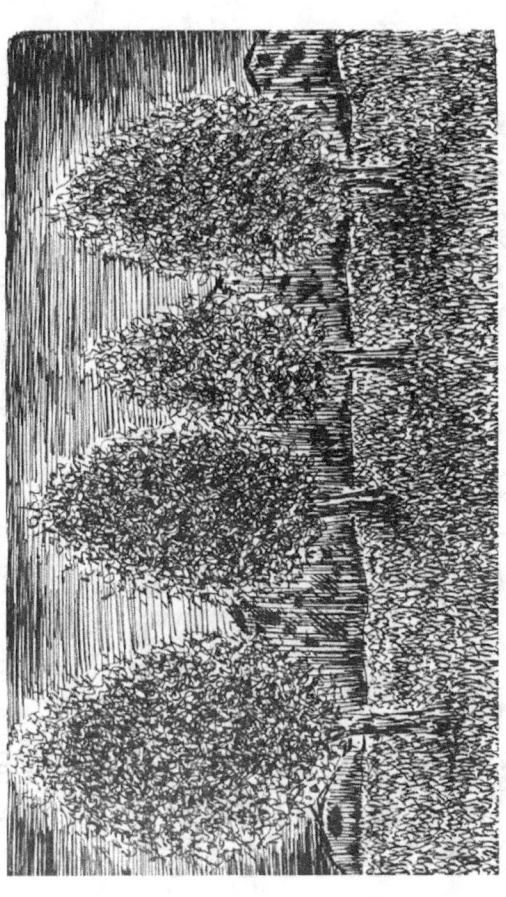

Here a backdrop of mountains is added. They are not properly visible as the trees covers most of the area. When the trees covers the area as here, it is better to leave the background element out.

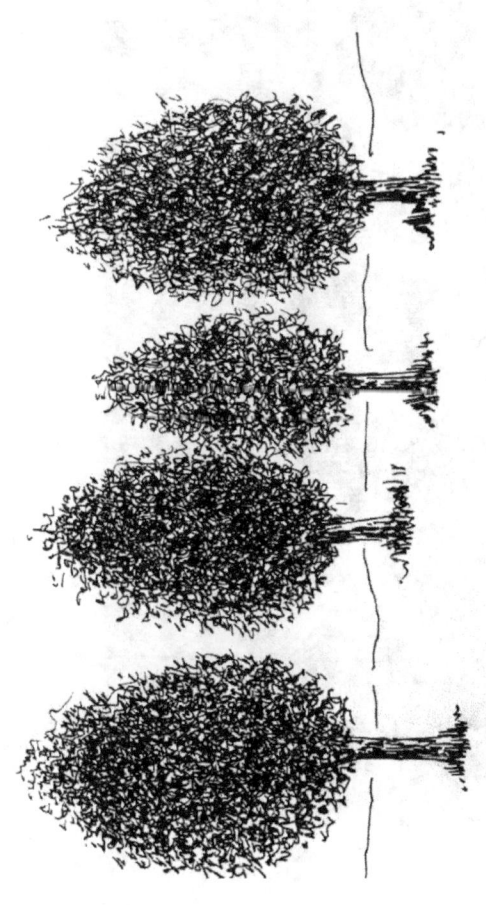

Start by drawing a group of trees. In the next step you decide on the other foreground elements and background elements to add, if any.

Composition Themes: Adding Trees, Continued

On last page, foreground trees crowded out the view of background element. Depending on the composition, foreground is sometimes the main focus. But if the background is desired to be seen as well, then use less density of trees with background visible between them. Following are 2 such drawings.

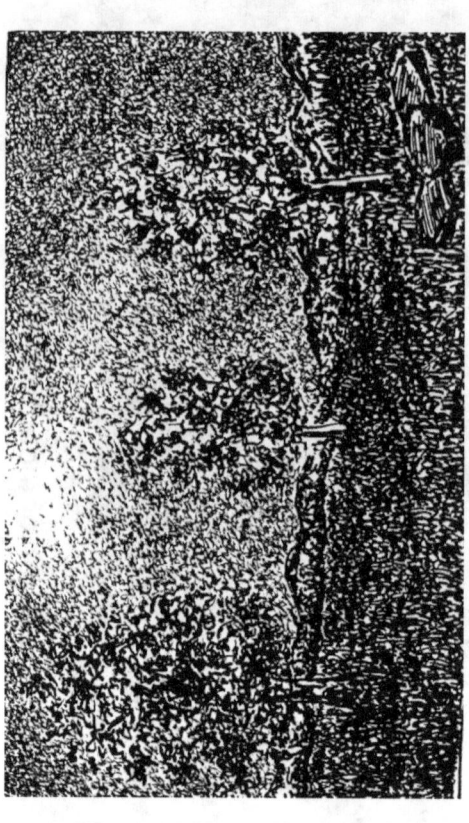

The mountains are drawn at a very small scale and barely visible here. Foreground trees are still the dominant elements in this drawing.

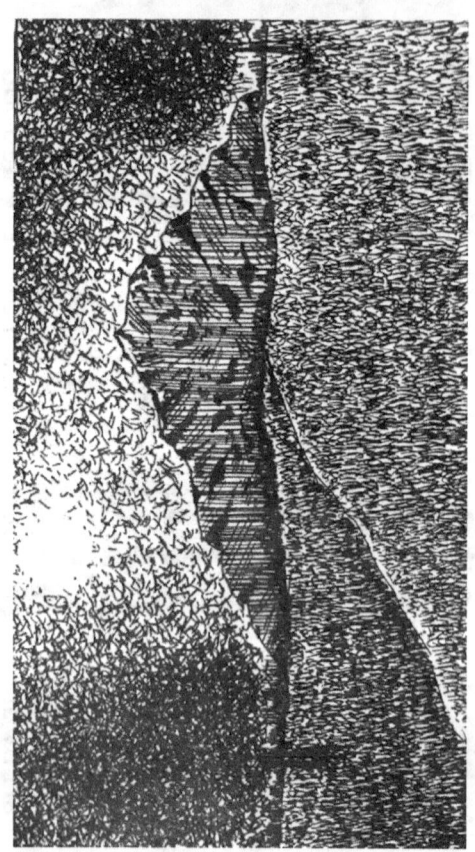

Here trees are added on the side with background mountain visible between them.

Drawing Trees:

Scribble stroke that was earlier used to texture sky, ground and hill can also be used to draw trees as shown below. Drawing trees is discussed in detail in vol. 1-2 of the workbook series. You can find more information on other workbooks at **www.pendrawings.me/workbooks**.

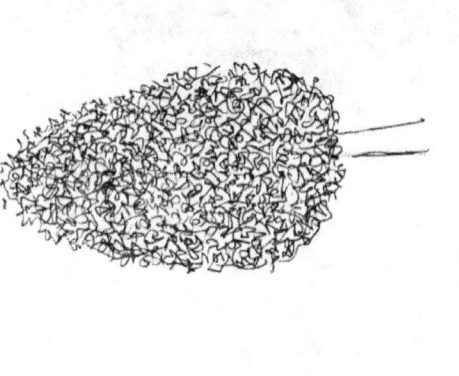

Use scribble stroke to add initial foliage in the tree outline. Here the tone is uniform and this doesn't give perception of depth in the foliage. This is corrected next.

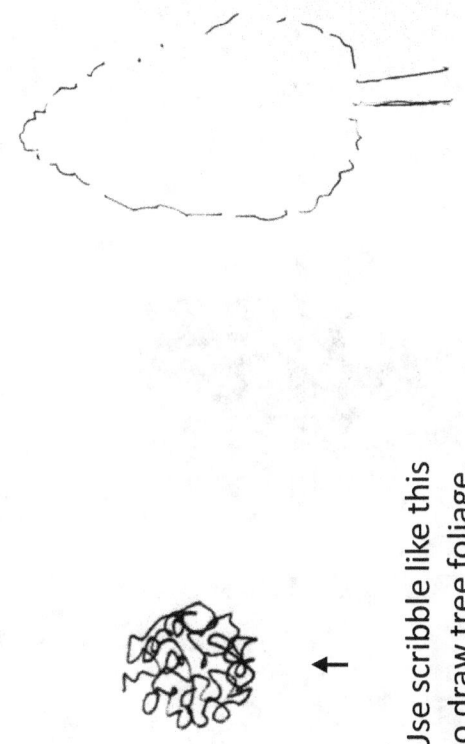

Draw an initial outline of the tree.

← Use scribble like this to draw tree foliage.

For more information visit www.pendrawings.me/getstarted

Drawing Trees, Continued:

To bring perception of depth in foliage, it is very important to vary tone, or add some darks in it. Darker foliage is perceived in the background while lighter areas are perceived as more Sun lit and hence in foreground. This combination gives foliage its depth.

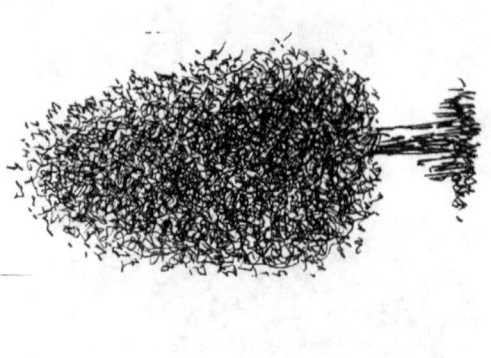

Use ticks marks as shown above to make edges open. Finish with grass as ground cover.

Use such ticks and marks to give feel of foliage at the edges of a tree.

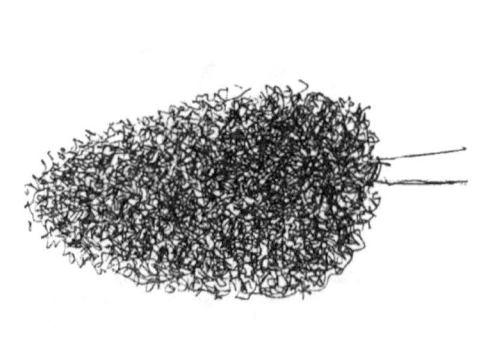

Add more scribble stroke in irregular manner to create tonal variations in the foliage. This creates perception of depth.

Activity: Drawing Trees:

Draw trees in the following outlines per earlier instructions.

Composition Themes: Forest Setting

Higher density of trees can be used to create a feel of forest and by darkening the sky, a feel of forest in night can be obtained. Creating a forest setting is discussed in detail in vol. 5 of the workbook series.

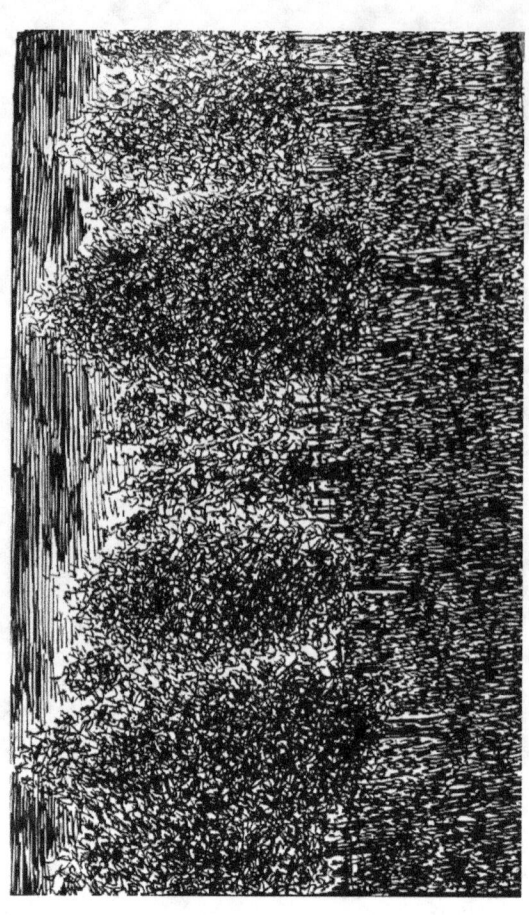

By adding sky and ground cover, a night setting is obtained with a feel of dense woods.

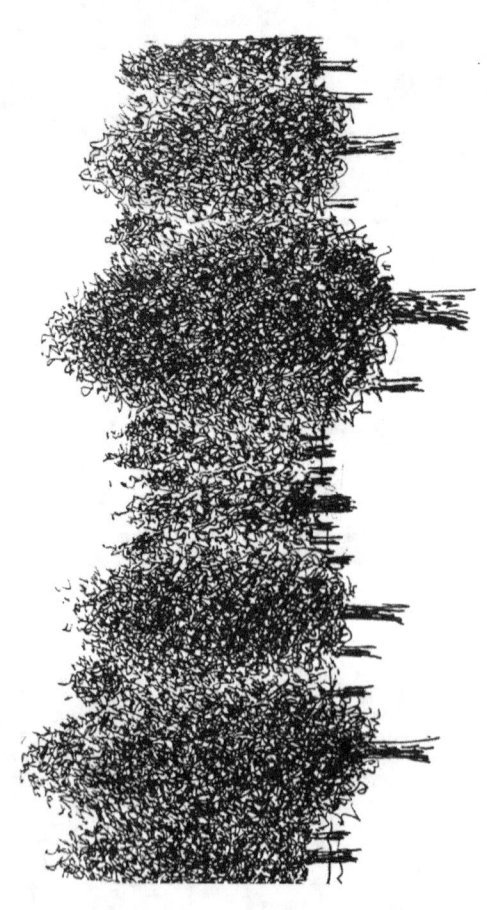

Start by drawing a dense layers of trees as shown above.

Composition Themes: Forest Setting, Examples

Following are some more examples of technique discussed on last page. By changing the density and location of such trees, very pleasing such nightscapes can be easily drawn from imagination anytime.

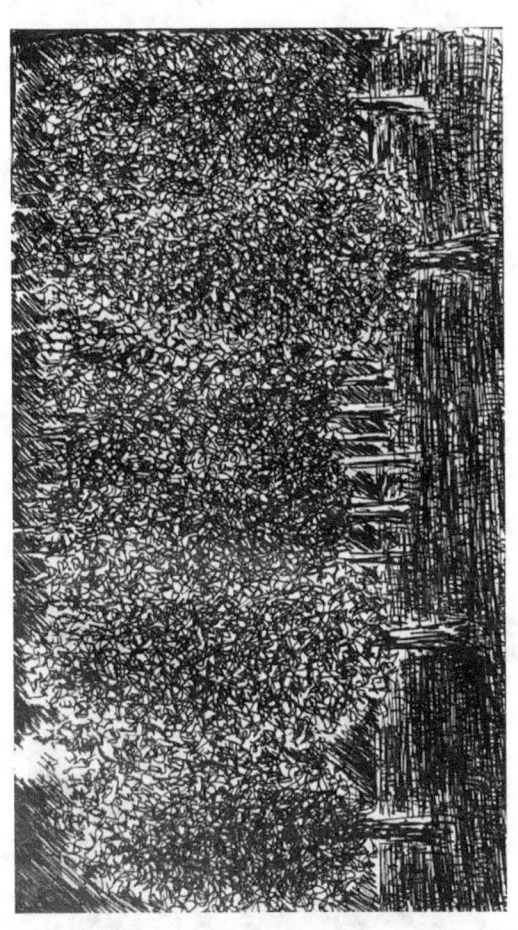

Here Sky is barely visible but the white of Moon is used to establish it and add visual interest.

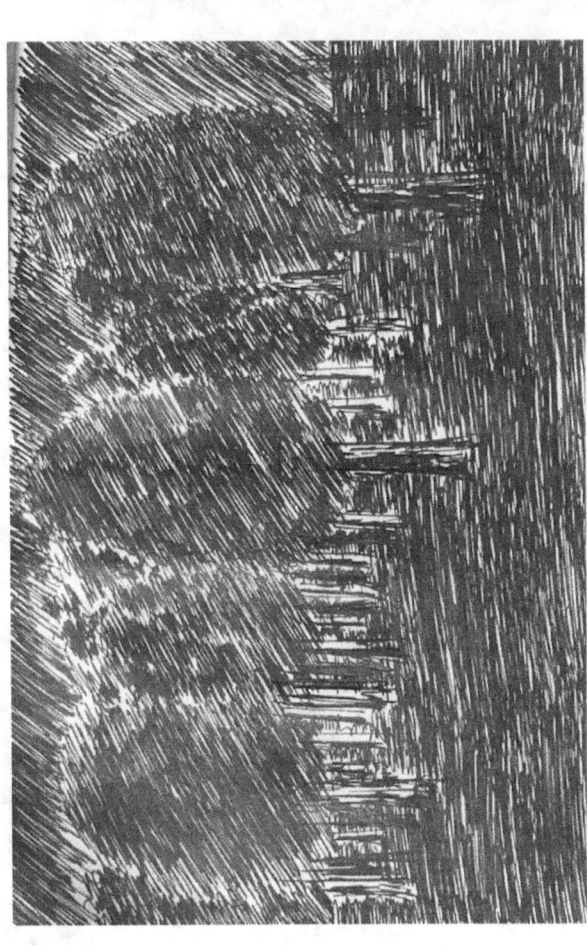

Notice that angular parallel lines are used to texture Sky here. This is another way to render sky, especially behind trees.

Composition Themes: A Wooded Setting

In vol. 5 of the workbook series, drawing different kinds of wooded setting is discussed. These wooded settings are very fun to draw and by adding a night sky, they can be turned into very pleasing nightscapes as shown below. For more information on vol. 5, please visit **www.pendrawings.me/vol5**

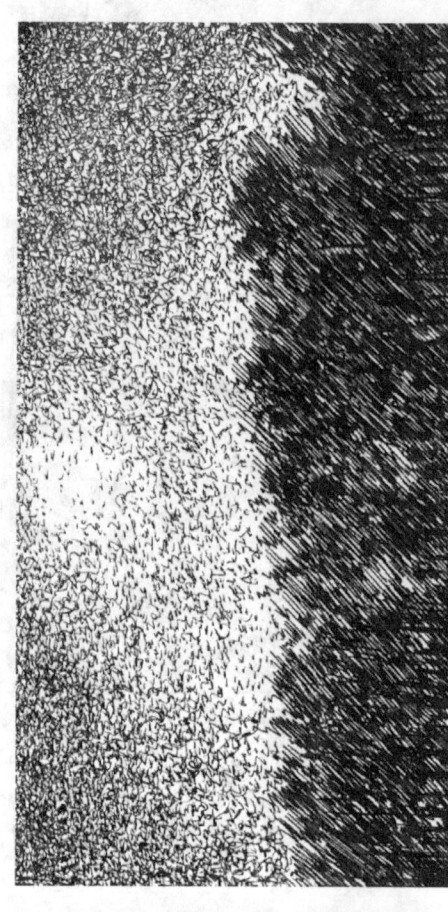

Here ground is not used. Instead, a wooded area is contrasted against a lit Sky to give a very pleasing appearance.

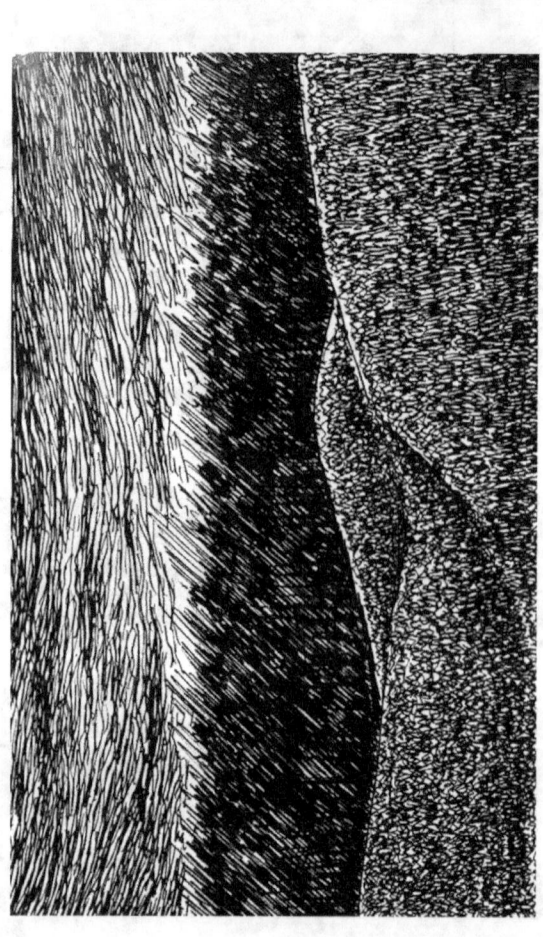

A wooded setting is usually darker in tone. A lighter Sky like above establishes a nice visual and tonal contrast against it.

Composition Themes: A Wooded Setting, Continued

Here are some more examples of nightscapes with wooded areas. Again notice the effect use of different strokes to render sky has on the feel of the drawing.

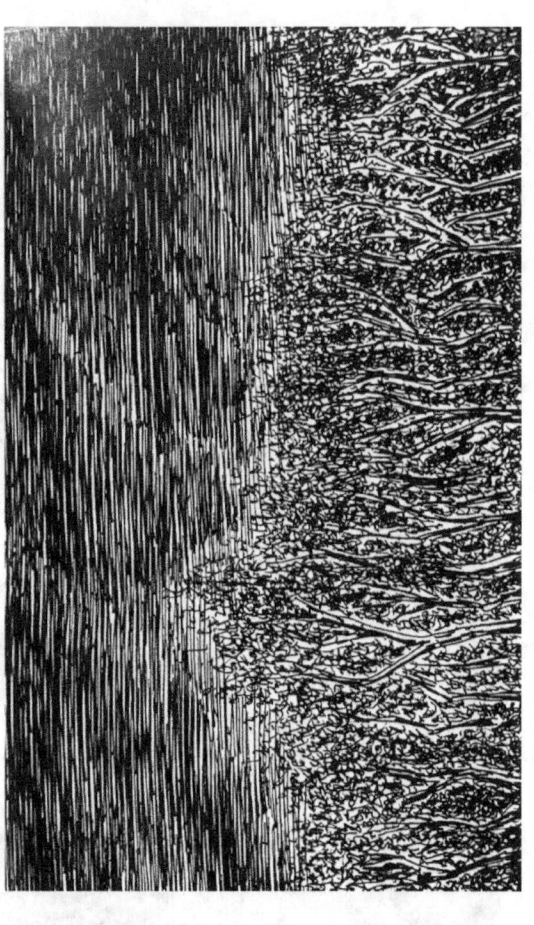

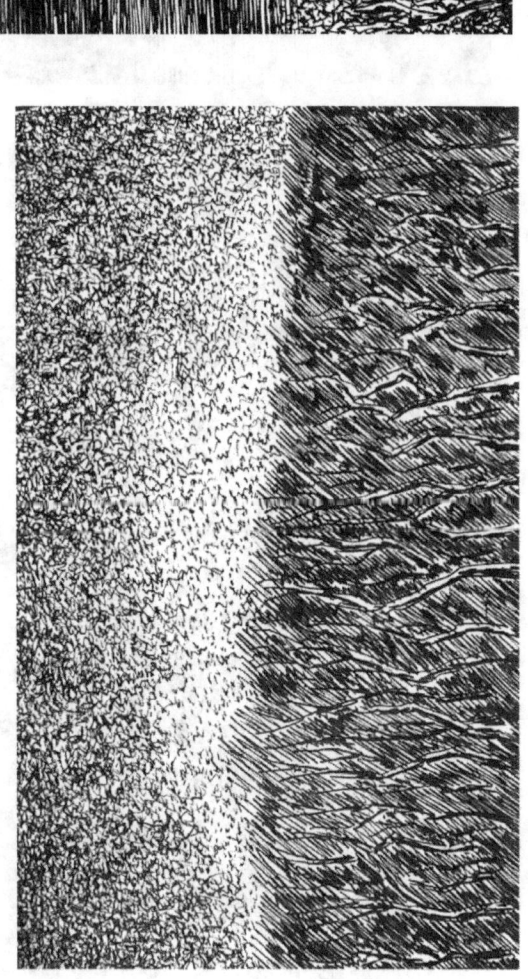

Pl. consult vol. 5 of my workbook series to learn how to draw such wooded areas. (www.pendrawings.me/vol5)

Composition Themes: Bare Winter Trees

Another fun nightscape composition is that of bare winter trees contrasted against a night sky. This has a bit of eerie feel to it but by varying the location and density of such bare trees and by using other elements in the drawing, quite dramatic effect can be obtained.

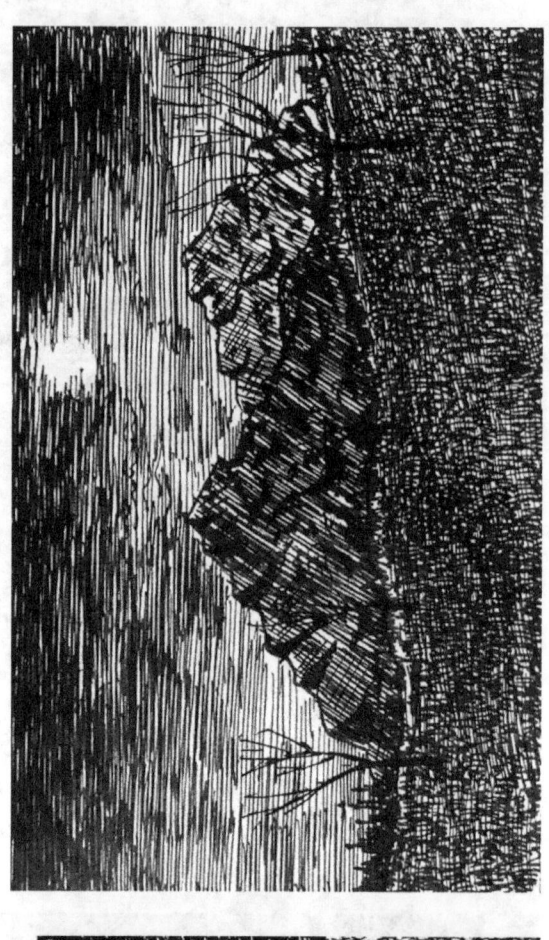

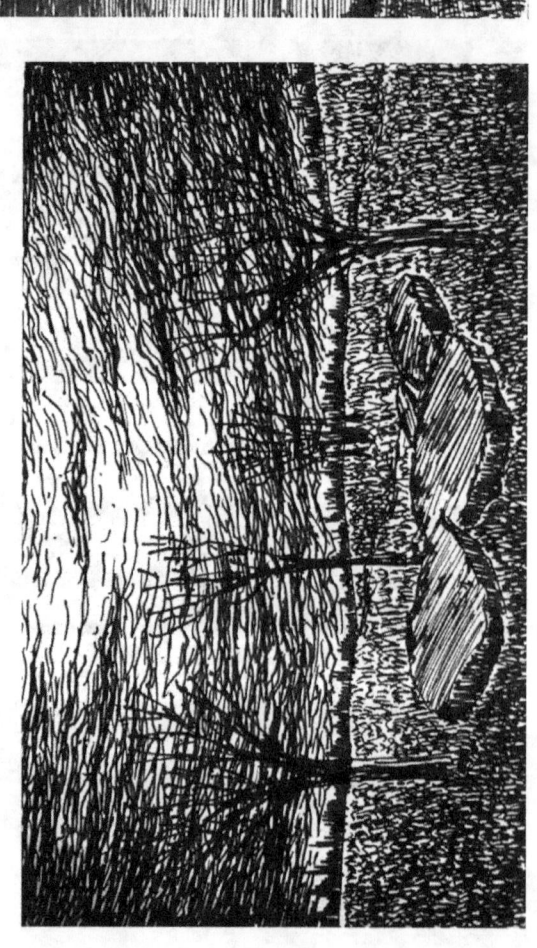

Make the bare trees visible by positioning them against the lighter area in the sky as is done above. Use different sizes of such trees to add more visual interest.

Composition Themes: A Distant Town

A distant town provides a nice backdrop to a nightscape. One simple way is to use a silhouette of a distant town as shown below against a rendered Sky.

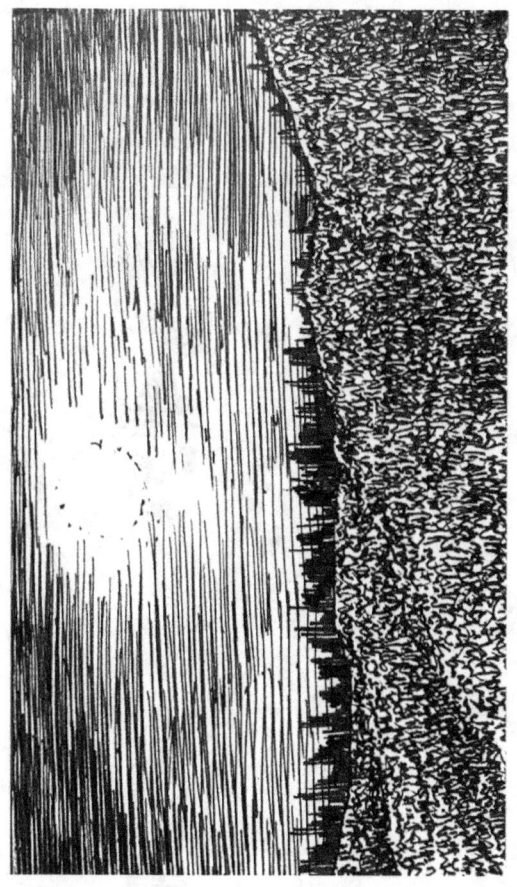

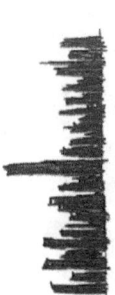

Silhouette of a distant town can be easily drawn by using such rectangles of different heights. Make sure to use combination of different heights to add visual interest.

Instead of a distant tree line, a silhouette of a town also creates a very pleasing night scape. By increasing the size of silhouette, it can be brought closer as well.

Composition Themes: A City Skyline View

Instead of just a silhouette like in previous page, more explicit buildings can be drawn to get a different feel as shown below. There is no limit to such interesting city outlines that can be drawn from imagination.

Start by drawing these rectangles representing buildings and other shape as appropriate. Use different heights to keep the outline interesting.

Fill the outline while leaving white representing windows as shown above. This is how easily a basic city skyline can be created.

To add more depth, add buildings behind and texture them as before.

Activity: Drawing a distant city Silhouette and Closer Skyline

Practice drawing distant town silhouette and closer Skyline as discussed in last few pages below.

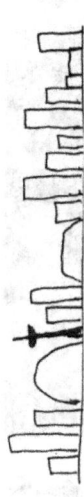

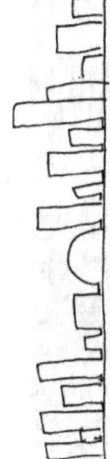

Composition Themes: A City Skyline View

Following are 2 drawings where city skyline as illustrated earlier is used. Reflection in water of the buildings further adds to visual interest in the drawing. In the second drawing, a combination of distant silhouette and closer skyline is used to further add depth to the drawing.

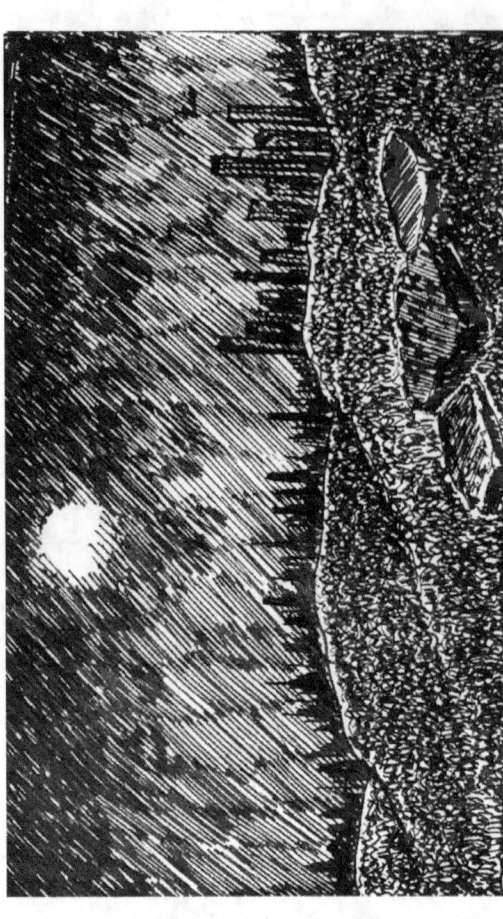

Here a combination of distant silhouette and bigger buildings is used to add more depth. Sky is also drawn using angular parallel lines which is yet another way to render night sky.

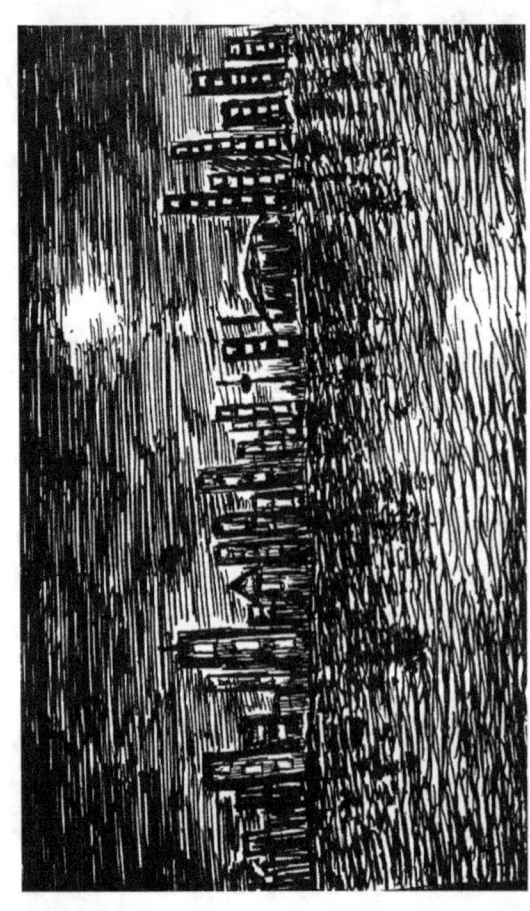

By drawing buildings bigger, they are brought closer. Also at bigger size, more details can be added as shown above compared to just a silhouette. Notice that I haven't used a ruler to make then perfectly vertical and hence the drawing has a 'sketchy' feel to it.

Composition Themes: Adding Water

Water is another element that can be added in the foreground in a nightscape to give it a special feel. One composition theme is to draw tall grass and other wooded areas behind a river flowing in front of them. Following are 2 such drawings. Drawing water is discussed in detail in vol.4 of the workbook series. Pl. visit www.pendrawings.me/workbooks for details on other volumes.

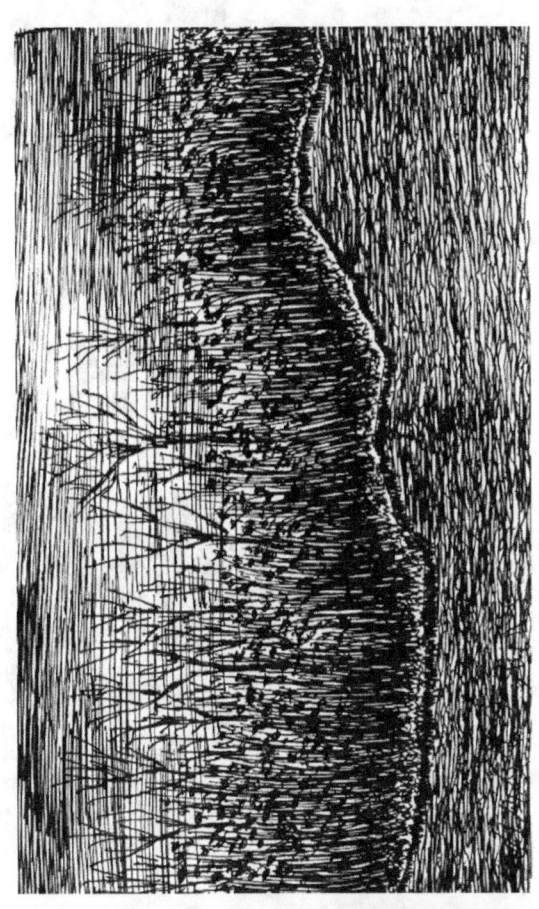

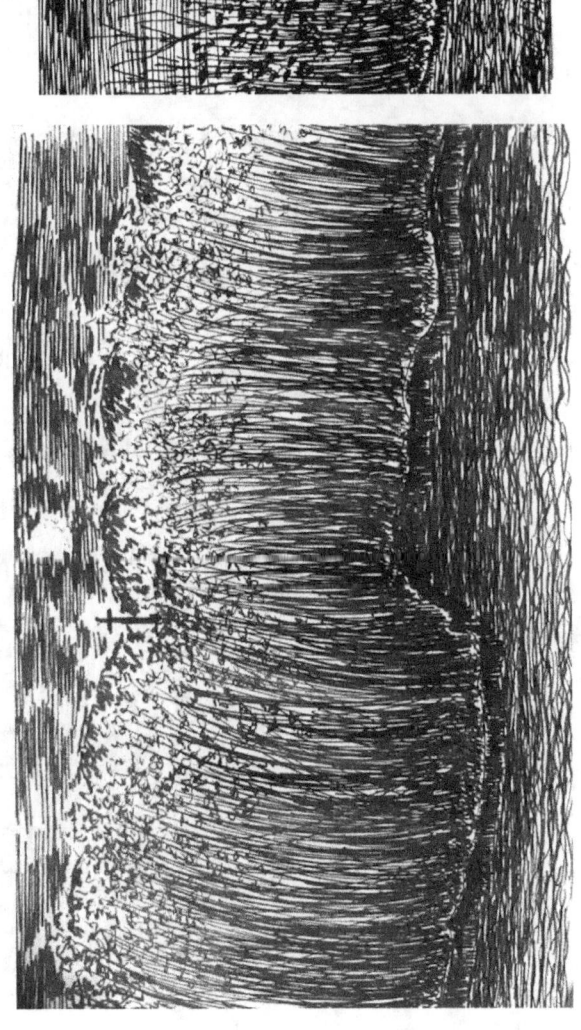

Composition Themes: Adding Water, Continued

Water can indeed be added in front of many composition themes we have discussed in this book. Following are 2 additional examples we saw earlier.

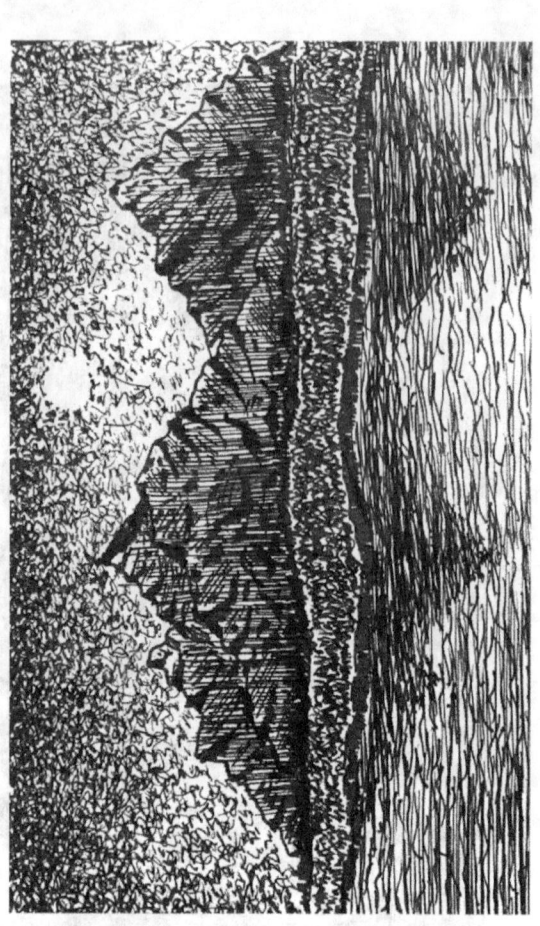

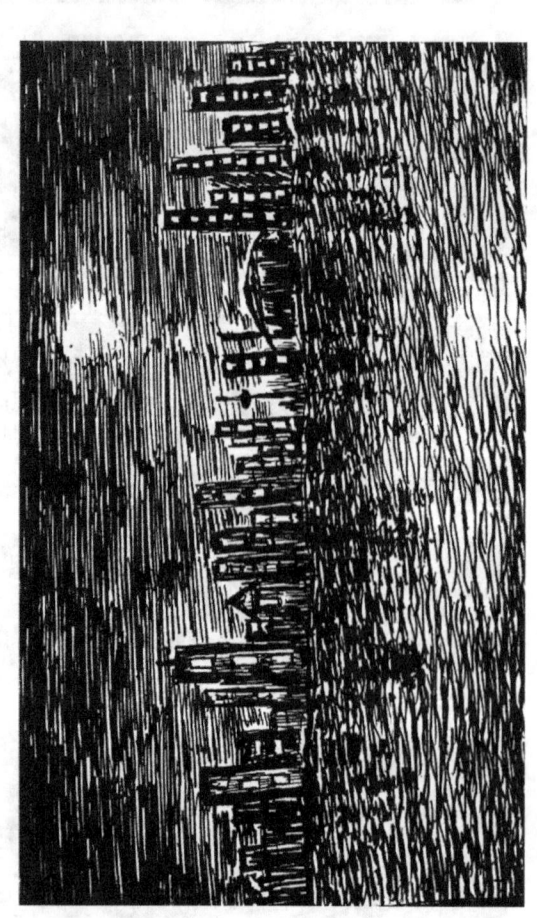

Composition Themes: Adding a House

A house against a night sky is a very pleasing composition and it appeals to our deepest emotions. Key consideration in this composition is the size of house to use. A closer view of house puts focus squarely on the house but precludes other elements that can set the ambience, like a looming mountain. In the second drawing below, presence of mountain adds a special appeal to the drawing. Drawing a house in perspective is very important and this is discussed in detail next.

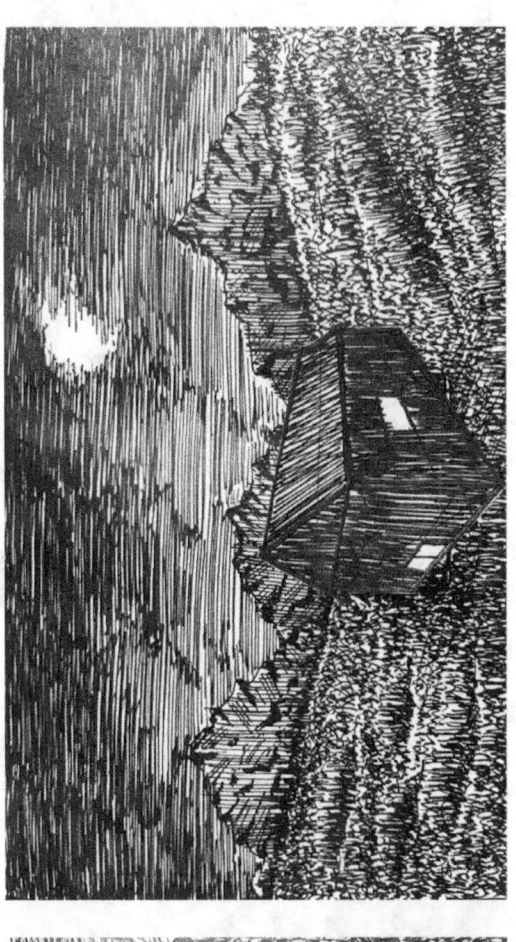

Closer view of house.

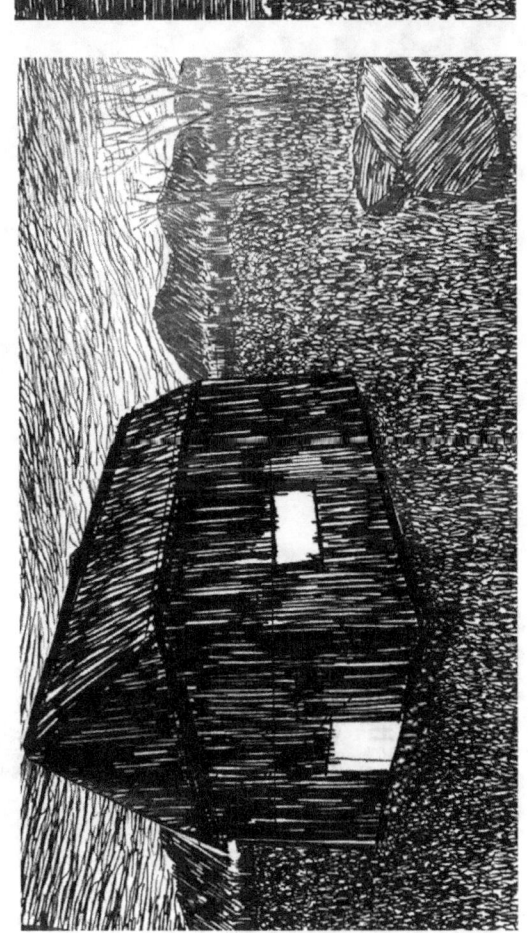

House is setback with looming mountains.

Concept of Perspective: Horizon and Vanishing Points

The concept of perspective can be explained with the help of following core point. For more detailed discussion on perspective, pl. visit www.pendrawings.me/perspective

1. The size of an object reduces as it goes further out from us. The far out distance where it becomes very small or invisible is called horizon. This horizon can be real in that we see it, or in some scenes it can be hidden by other elements in front. In this case it is 'implied'.

As a simple example, consider the wooden post below. As this post will get away from us, it will become smaller. The question is **how small will it be at different distances from us?**

To answer that we draw **converging lines** from the top and bottom of the post to a point on horizon. This point is called **vanishing point** as here the post is so far from us that it has 'vanished' from our view.

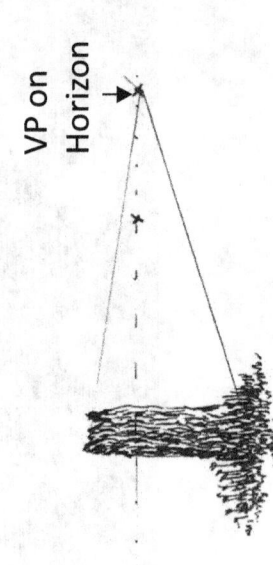

VP on Horizon

Location of VP on Horizon is determined by the angle at which the object is receding to the horizon.

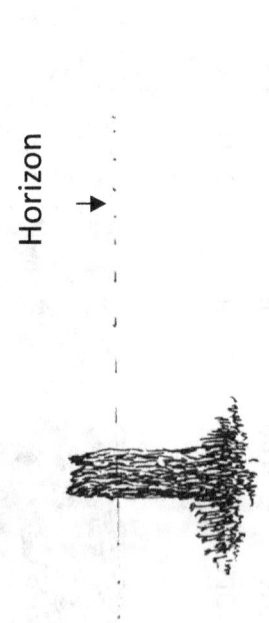

Horizon

Concept of Perspective: Horizon and Vanishing Points

Once the converging lines from an object to a Vanishing Point on the horizon are drawn, relative size at different distances can be easily determined as shown below'.

Now the size of posts at different distances is easily determined as being in between these lines. This gives us the decrease in height with the distance. The posts must also be made less thicker with the distance.

Notice how the posts appear to recede and become smaller 'convincingly'. This is so because with perspective there is a consistent 'ratio' to their becoming smaller, just the way our eyes perceive the natural world.

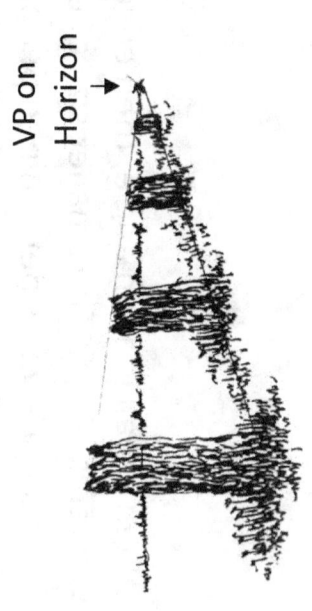

Size of Posts at different distances is between the converging lines

 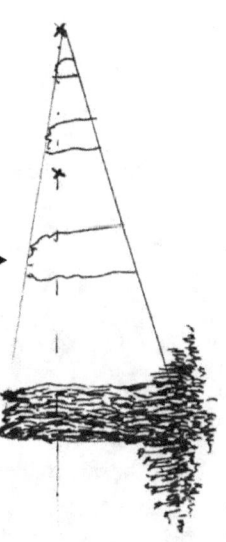

VP on Horizon

Concept of Perspective: Drawing a Wall

On last page we saw how individual elements like posts become smaller with distance due to perspective. Same concept hold for bigger objects like a wall that is at an angle to the horizon.

When a wall is directly facing the viewer then for that side perspective doesn't come into play.

Perspective is not relevant for the side directly facing the viewer

When a wall is at an angle, then edge closer to viewer is bigger. The smaller size of edge away from the viewer is determined per perspective as before by using converging lines going to a vanishing point.

Left edge drawn per need

Right edge is determined using perspective

Concept of Perspective: Drawing a Wall, Continued

If a wall has individual elements like stones/bricks, they should be drawn in perspective as well as shown below.

Stones/Bricks in a wall should be drawn in perspective using multiple converging lines as shown below.

Draw converging line for each row of stone/brick

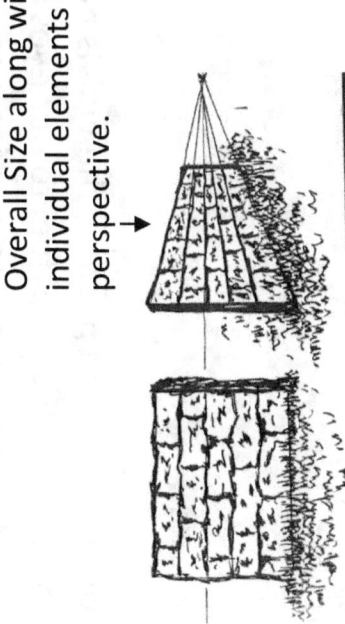

Using these multiple converging lines, individual stones/bricks can be drawn in perspective for a more convincing feel.

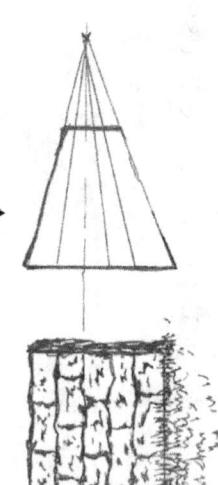

Overall Size along with individual elements in perspective.

Concept of Perspective: Drawing a Wall, Continued

For a thicker wall, the thickness also needs to be drawn in perspective. This technique where 2 sides (here length and width) are drawn in perspective is called 2 point perspective as 2 vanishing points on either end of horizon are used for 2 sides. 2 point perspective is used to draw a house as discussed next.

Same approach is used on the left side for drawing thickness of wall in perspective.

With both sides in perspective, the wall is now complete. It has a 'normal' feel to our eyes which won't be the case if both sides were not in proper perspective.

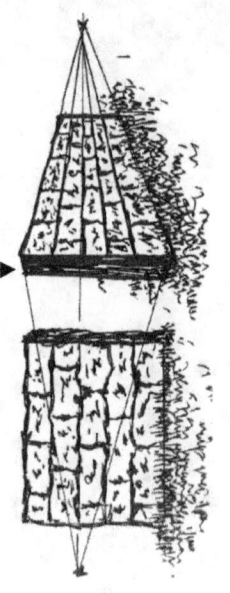

Width in perspective. It is again decreasing in size towards horizon.

Converging lines for left side (width)

Left VP

Drawing a House in Perspective: Left and Right Side

To draw a house in perspective, we need to first establish our Vanishing points (VPs) on the horizon. These VPs determine how the sides will slope in perspective. This is per 2 point perspective that was illustrated in last few pages. For more detailed discussion on perspective, pl. visit **www.pendrawings.me/perspective**

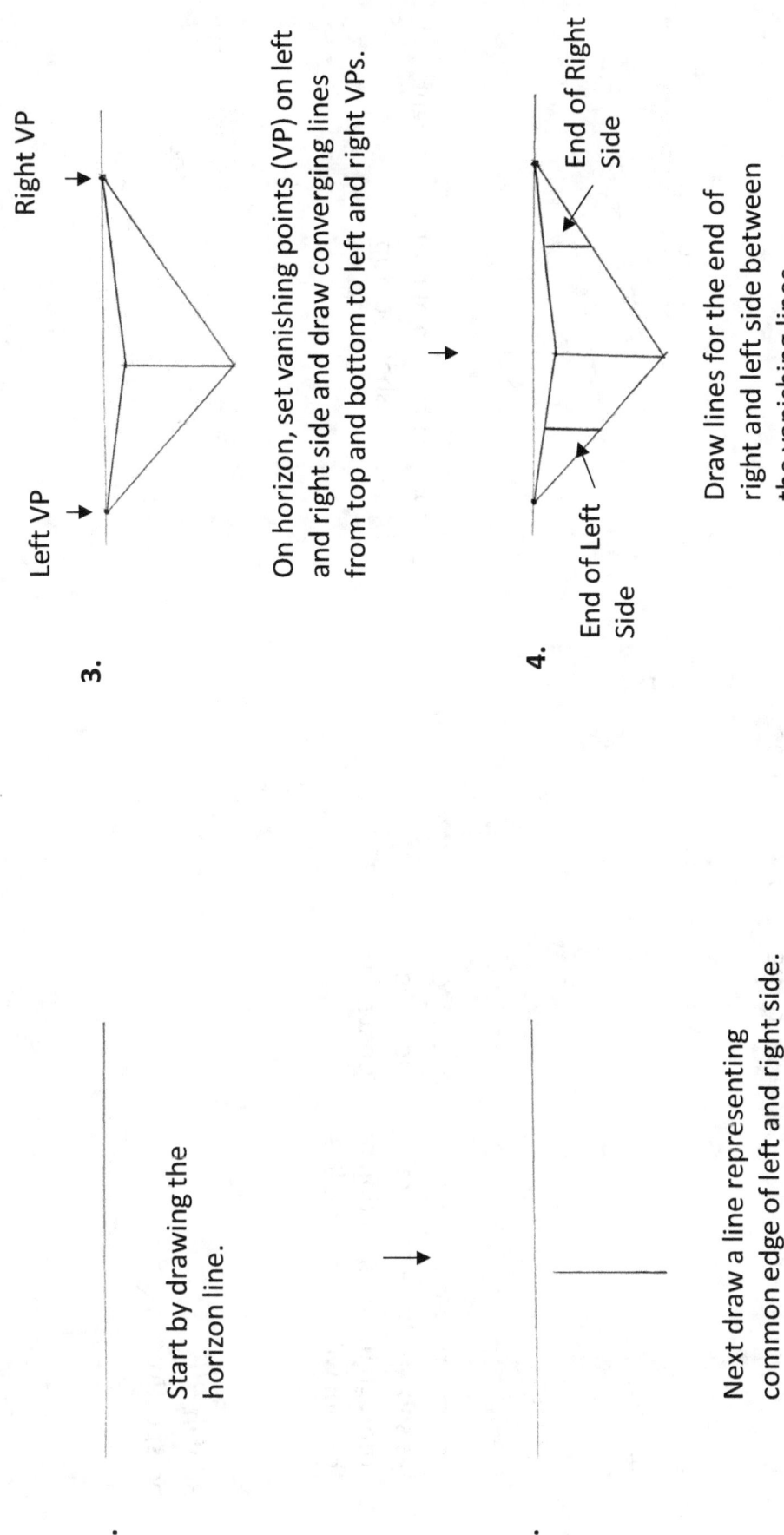

1. Start by drawing the horizon line.

2. Next draw a line representing common edge of left and right side.

3. On horizon, set vanishing points (VP) on left and right side and draw converging lines from top and bottom to left and right VPs.

4. Draw lines for the end of right and left side between the vanishing lines.

Drawing a House in Perspective: Adding Roof

A roof in perspective can be added with the following steps.

5.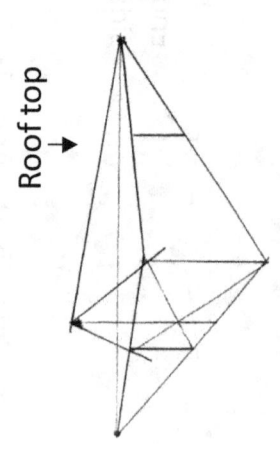

Roof line

To draw roof, on the left side draw an X as shown above and draw a vertical line through the intersection point. Center of roof will rest on this line

6.

Roof in perspective

Draw lines from top of roof line as shown above to establish roof in perspective.

7.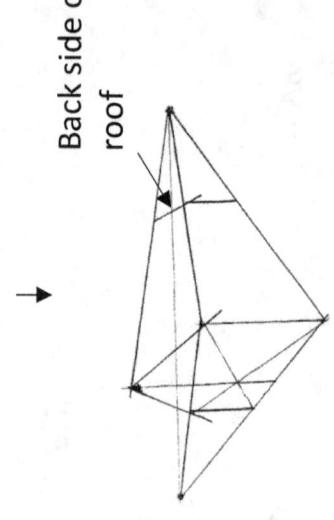

Roof top

Next connect the top of roof line to right VP. This establishes roof top.

8.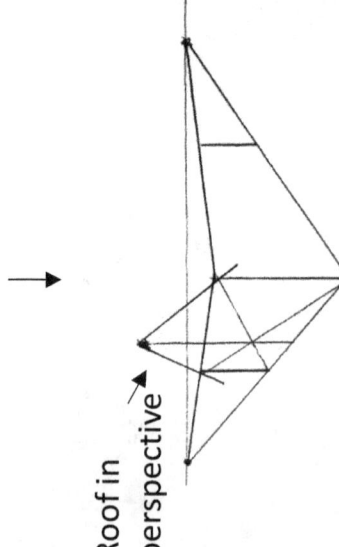

Back side of roof

Finally add back side of roof as shown above to complete roof. Right angle for this line involves more perspective but usually it can be visually added with pleasing appearance.

Drawing a House in Perspective: Adding Door and Windows

Doors and windows also needed to be added in perspective: They can be done as show below.

9.

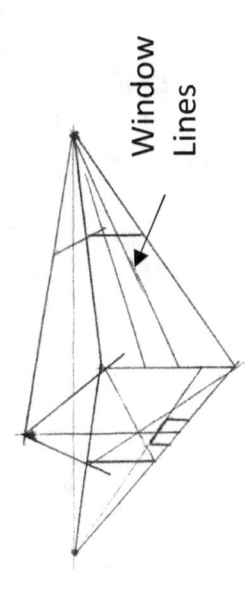

Door line

Draw a door line as shown above going to left VP.

10.

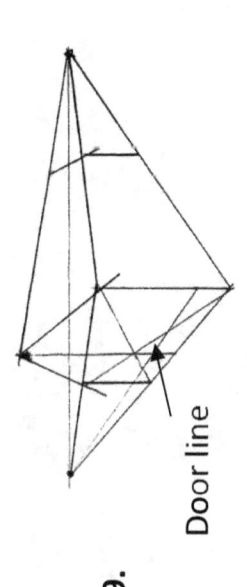

Door in perspective

Draw vertical lines to draw door in perspective.

11.

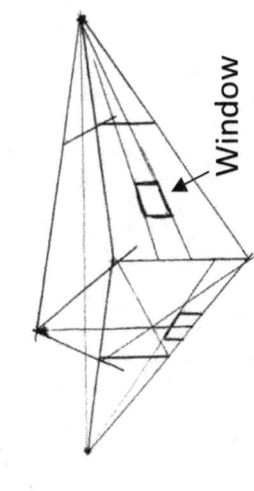

Window Lines

To draw windows, draw two window lines as shown above.

12.

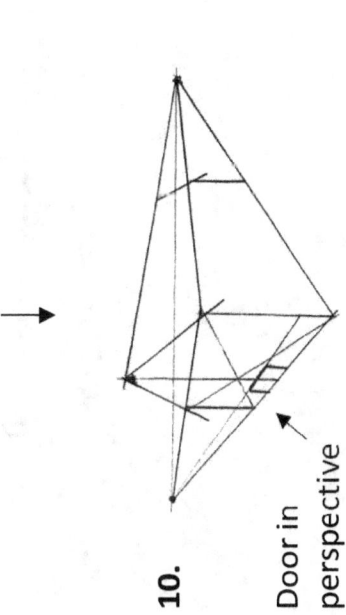

Window

Draw vertical lines between window lines to draw windows in perspective.

Drawing a House in Perspective: Texturing

After a house in drawn in perspective using steps described in last few pages, it can be textured using short parallel lines to give it a feel of wood as shown below. Leave the roof lighter than sides as it receives more moonlight and is hence lighter. Leave the doors and windows white to give it a night effect.

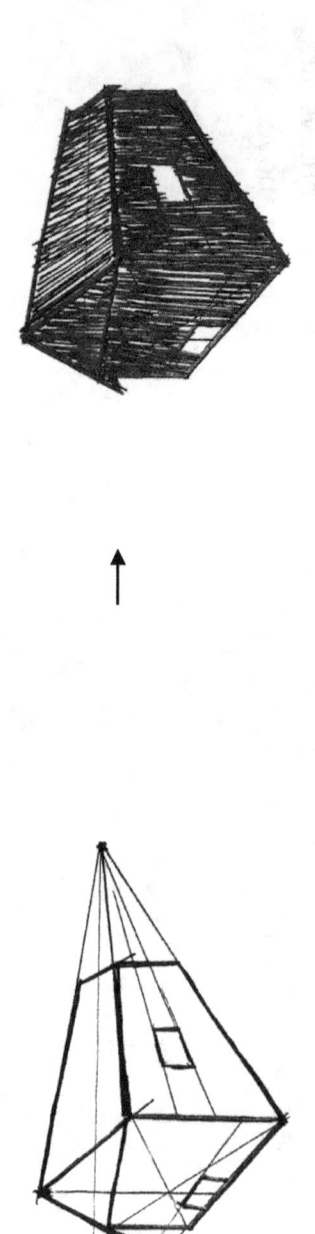

Composition Themes: A House, More Examples

After you have practiced and can drawn a house in perspective, following type of landscapes can be drawn. First a horizon is established and next a house is drawn per perspective as discussed in last few pages. After that other elements are drawn and textured as before. By changing the location and size of houses, many variations on this theme can be drawn.

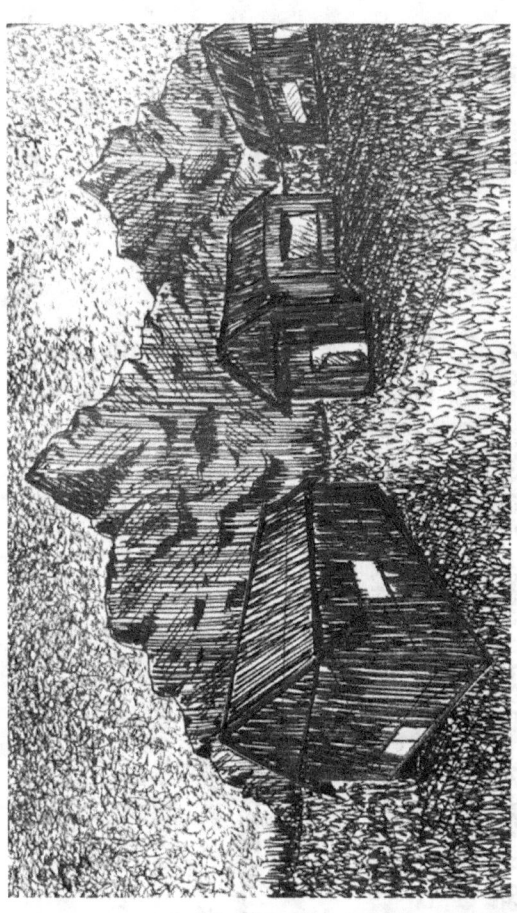

Final Thoughts:

This completes this workbook but hopefully this is just the beginning of your pen and ink drawing adventure. As you hopefully saw in this workbook, drawing a nightscape is very fun and quite easy to do once few simple techniques to render night sky and other elements are understood and practiced. Various composition themes presented here will give you guidance in your initial attempts at drawing nightscapes but don't be afraid to combine them and even create your own once you feel confident enough.

Key is to start somewhere and then practice. Small daily practice is ideal. Carry a pocket sketch book and pen with you and in between your breaks trying putting drawings as illustrated in this workbook. Don't let initial frustration stop you in progressing on your creative journey. With practice you will steadily improve and discover that drawing is not just for 'artists' but is something that can be part of all of us in exploring and expressing our creative sides with a simple medium like a pen and paper.

Don't be afraid to explore with pen. Let your hands express freely and without reservation. If you feel like making a scramble of lines, do so. A big part of drawing with pen and ink is letting go of your inhibitions about use of pen and specifically putting a 'wrong' line. With simple strokes and techniques presented in this and other workbooks in the series, I am confidant that you have the information you need to get started on this wonderful journey.

You can visit my website for completely free tutorials and use other workbooks I have created to learn how to draw other elements of nature, like trunks, stones etc. with pen and ink and create more interesting landscapes.

www.pendrawings.me/workbooks

Any comments, suggestions and feedback on improving contents of this workbook are most welcome. For more information on drawing landscapes with pen and ink, to learn more about my works and to reach me, please visit my website at www.pendrawings.me/getstarted

Happy drawing,

Rahul Jain

Silent Night: Copyright Rahul Jain.

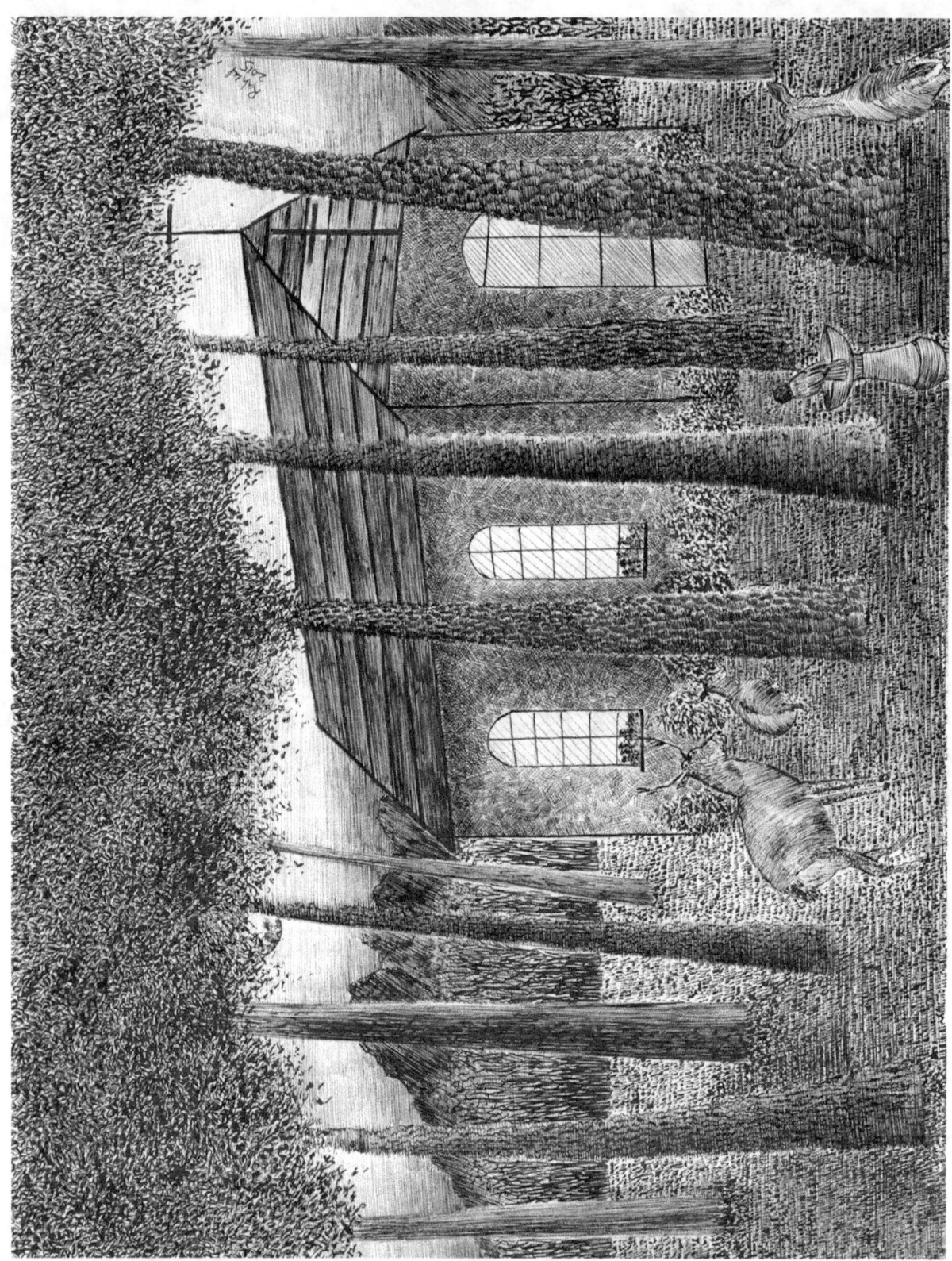

Blessed Night: Copyright Rahul Jain

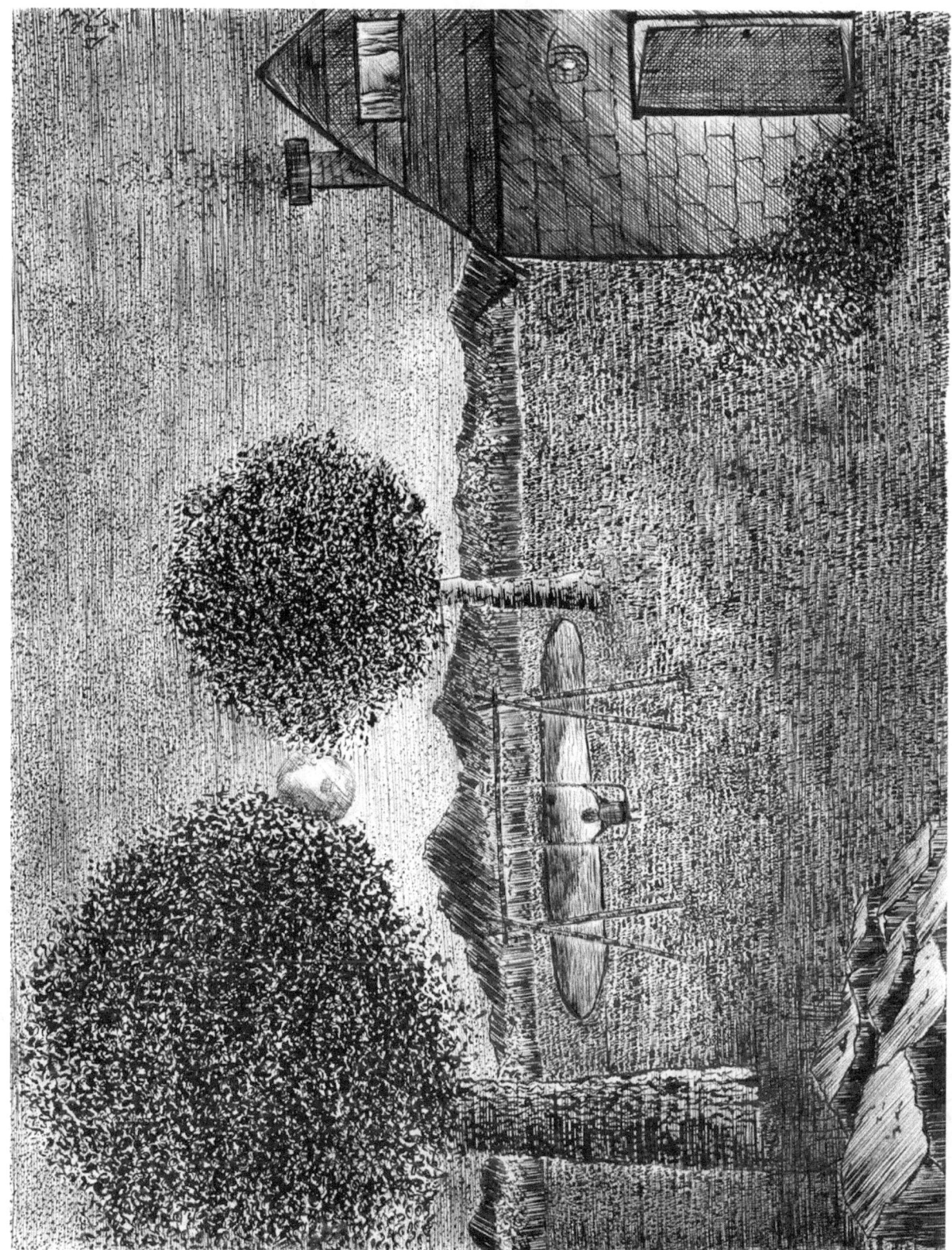

Magical Night: Copyright Rahul Jain

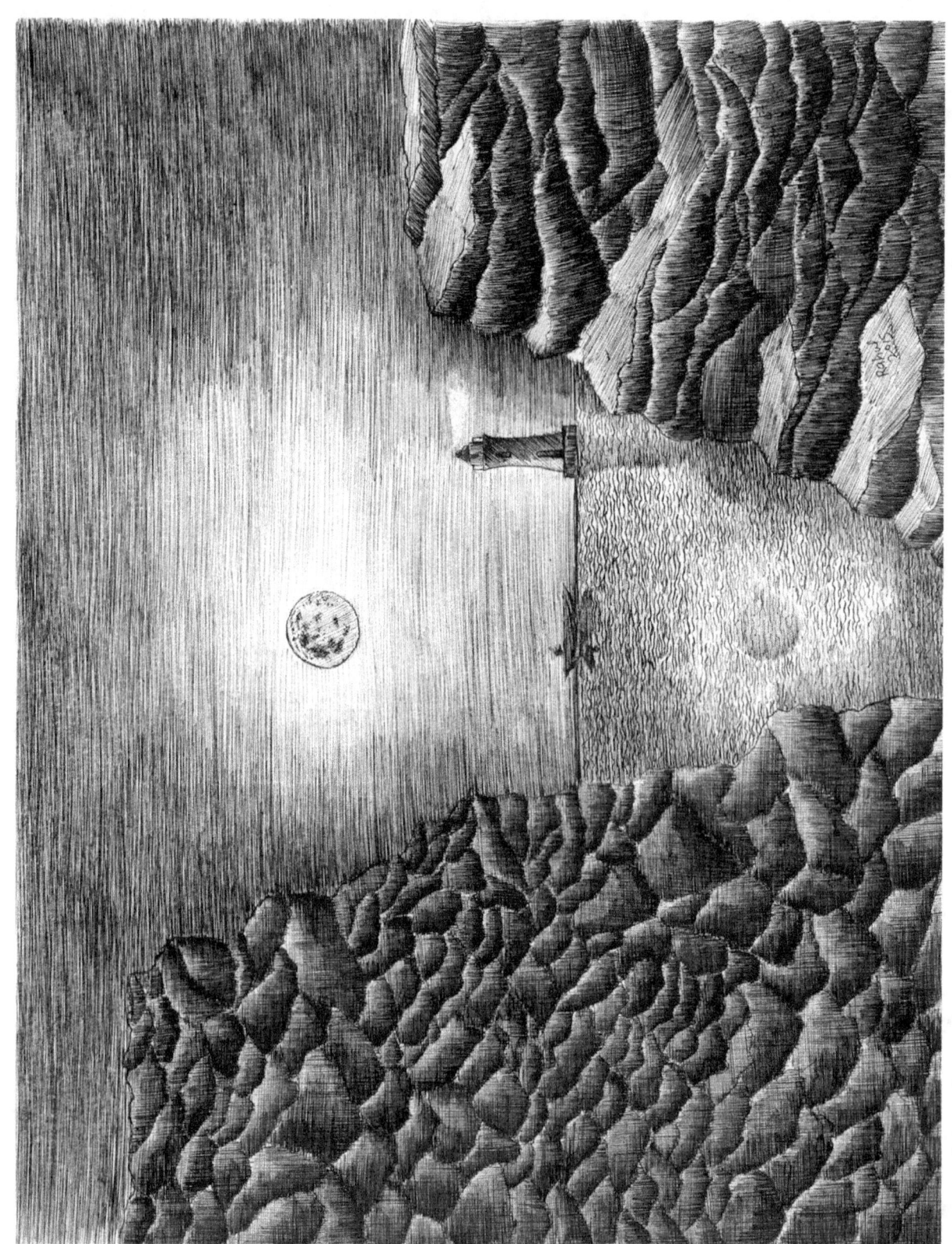

Beautiful Night: Copyright Rahul Jain

A Peaceful Night: Copyright Rahul Jain

www.ingramcontent.com/pod-product-compliance
Lightning Source LLC
Chambersburg PA
CBHW081603220526

45468CB00010B/2756